Carving Caricature Head & Faces

W. "Pete" LeClair

Text written with and photography by Douglas Congdon-Martin

33

Caricatures with Step-by-step Carving Instructions

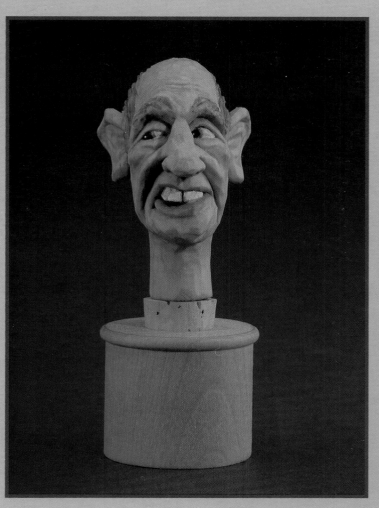

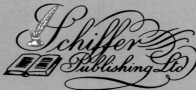

Schiffer Publishing Ltd

77 Lower Valley Road, Atglen, PA 19310

Contents

Dedication

This book is dedicated to my two grandchildren, Kaitlyn and Amanda, who are the light of my life. May they share in the joy of my achievements and have the opportunity to create their own.

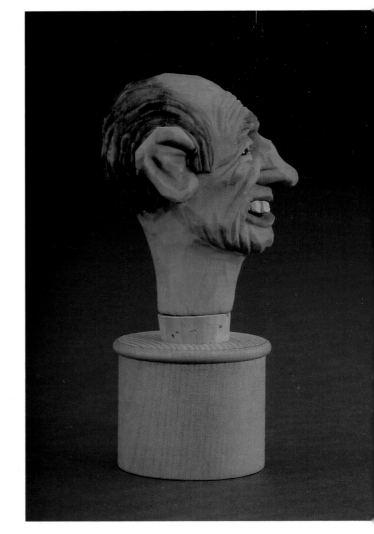

Acknowledgments

The opportunity to publish a book may happen once in a lifetime. I would like to share, with my readers, the people along the way who have contributed to my success. I am extremely grateful to a host of individuals for their relentless and unwavering encouragement. If it were not for these people in my life, this book would not be a reality.

Thank you to Rose and my two sons, Mike and Eddie, who have always displayed enthusiastic support, along with patience and understanding.

And a sincere Thank You to:

Al Verdini, for introducing me to caricature wood carving;

Fran Capone, a friend who exhibited constant support;

Henry Fredericks, for technical assistance and promotions;

Larry Spinak, a special thanks for technical painting assistance;

Ron Boone, John Marino, & Bill Brailey, carving buddies who know the pleasures and difficulties involved;

Central Massachusetts Caricature Carvers Club (C.M.C.C.), fellow members for their continuous support;

Jack Price and Dave Dunham, for sharing their ideas and inspiration.

Book design by Audrey L. Whiteside

This book is meant only for personal home use and recreation. It is not intended for commercial applications or manufacturing purposes.

Printed in China.
ISBN: 0-88740-784-6

Library of Congress Cataloging-in-Publication Data

LeClair, Pete.
　　Carving caricature hands & faces: 33 caricatures with step-by-step carving instructions/Pete LeClair: text written with and photography by Douglas Congdon-Martin.
　　　　p.　　cm.
　　ISBN 0-88740-784-6
　　1. Wood-carving--Technique. 2. Head in art. 3. Face in art.
I. Congdon-Martin, Douglas. II. Title.
TT199.7.L43　1995
731'.82--dc20　　　　　　　　95-15653
　　　　　　　　　　　　CIP

Published by Schiffer Publishing, Ltd.
77 Lower Valley Road
Atglen, PA 19310
Please write for a free catalog.
This book may be purchased from the publisher.
Please include $2.95 postage.
Try your bookstore first.

We are interested in hearing from authors with book ideas on related subjects.

Introduction

I have always loved faces. I spend hours looking at them and observing the variety of shapes and features they have. I think they reveal a lot about the person, though I'm not sure whether the personality affects the face or the face affects the personality. Whichever way it is, a person and his face usually belong together!

When I started carving I was naturally drawn to the face, and particularly to caricature. I enjoy enhancing the features just a little with exaggeration to make them more powerful and more interesting.

Now that I teach, I find that other carvers are interested in my methods for creating these characters. Over the years I have developed a step-by-step method that is pretty close to fool proof. They help the carver get a face that has the correct proportions of the human head, a difficult, but important, part of caricature carving. While the features may be exaggerated, the overall structure of the head must be correct or it will not be believable to the observer. With that done, I help the carver add the features that make the face humorous and charming.

This is a basic book, focusing on the head. It begins with cutting the blank and ends with painting the figure. You may use it to learn to carve full-figured caricatures or simply to create bottle stoppers as I do here. Whichever you choose, I hope you enjoy this hobby as much as I do.

Carved by John Marino

Carved by Larry Spinak

Carved by John Marino

Carving the Head and Face

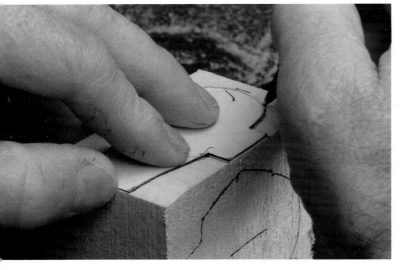

Draw the front and side patterns on the wood.

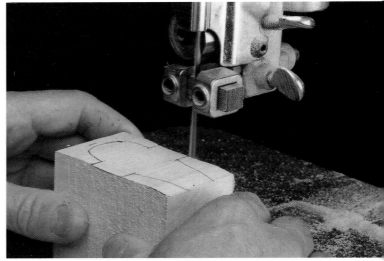

and the bottom of the ear. Repeat on the other side.

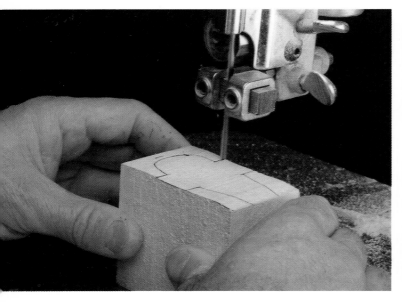

I always cut the front view first so I have a flat surface to cut out the profile. First, cut in at the top of the ear...

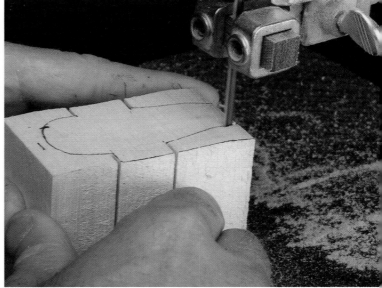

Come up from the bottom of the neck...

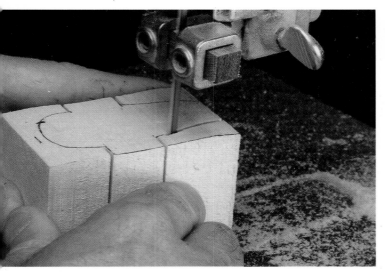

and stop about 1/4" before the ear cut. This leaves the wood intact for the profile cut.

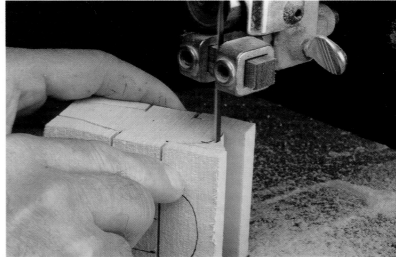

and the other.

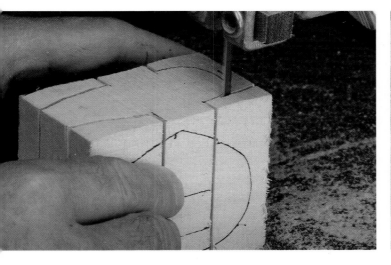

Cut down from the top at the sides of the head, again stopping about 1/4" from the ear cut.

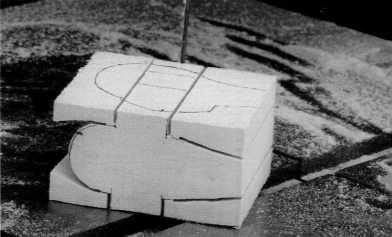

The result. By not finishing the cuts, I get a nice flat surface to work with for the profile cuts.

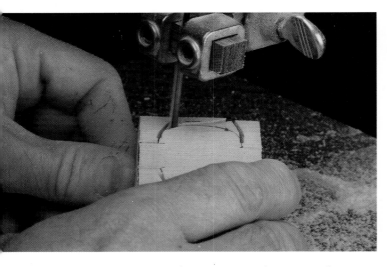

Clean out the area between the two top cuts by cut into the them from one direction...

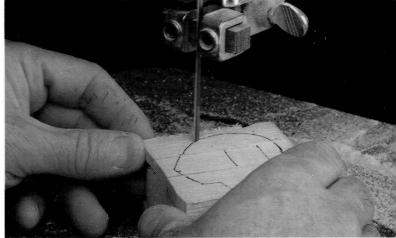

Cut the profile of the head. Out of habit I usually start at the top and come down the front of the head...

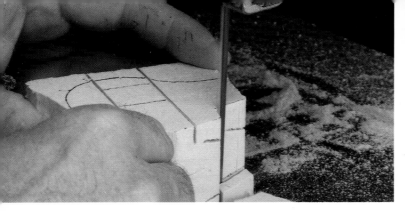

finishing with the neck.

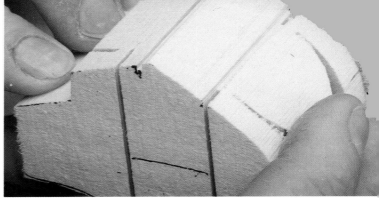

By touching the head lightly to the bandsaw, I get these shallow reference points.

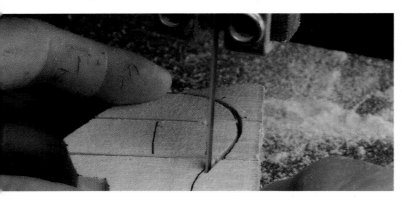

Then I cut down the back of the head.

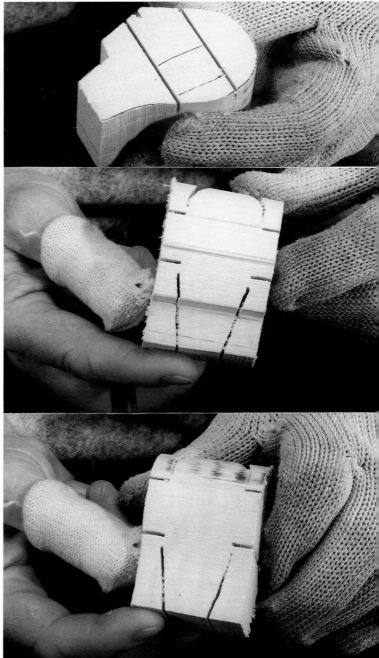

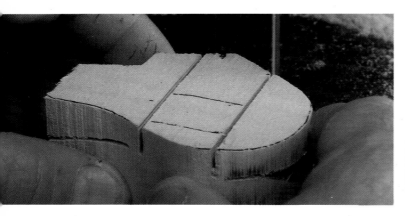

I recommend that you put two reference notches for the nose, one at the top...

and one at the bottom.

Ready to carve.

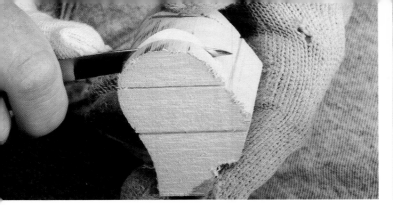

I want to break off the four corners. This is simply done by putting the knife blade in...

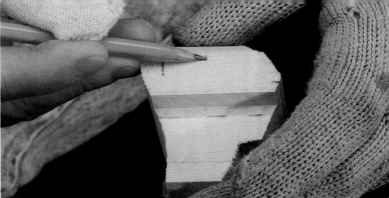

to the other side.

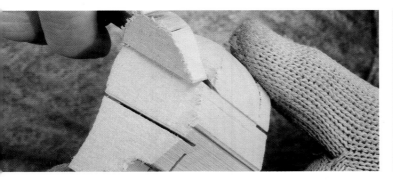

and giving it a twist.

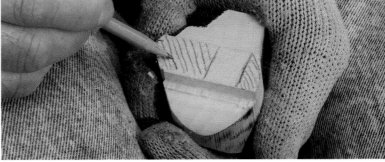

The shaded areas will be removed to bring out the ear.

Because you are going with the grain, you get these nice, clean breaks.

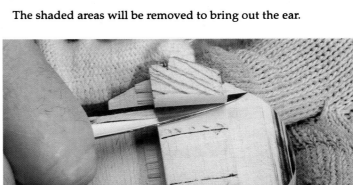

Working from the front of the ear, relieve the wood to the level of the neck.

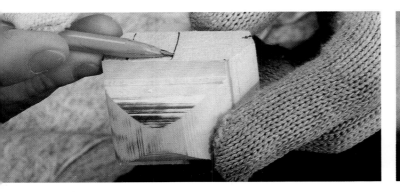

Use your finger as a depth gauge, and transfer the lines of the ear from the side of the blank with the pattern...

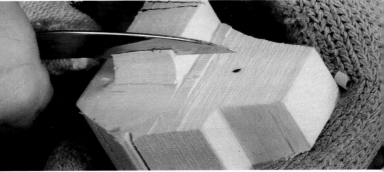

Define the front of the ear by cutting a stop straight down on the line...

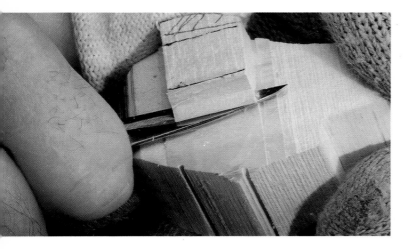

and coming back to it from the surface.

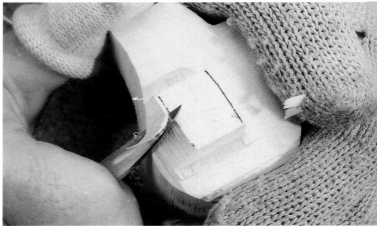

and continue with a bevel cut until you get to the line.

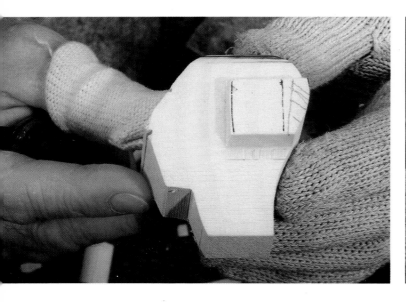

The result.

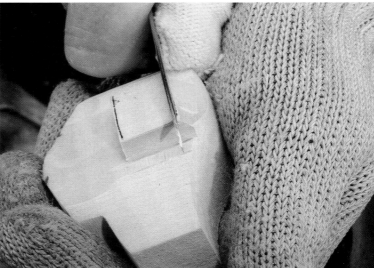

With the excess removed, I cut a stop straight down behind the ear, as before,

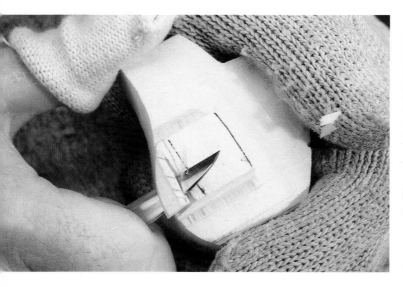

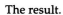

The area behind the ear will be removed in a similar way, but first I cut with the grain to pop off the excess...

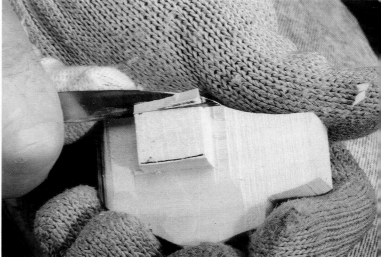

and cut back to it from the surface.

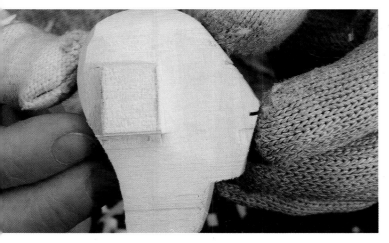

The result. Repeat on the other side.

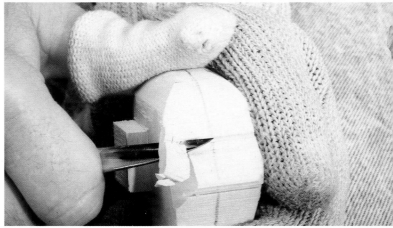

remove the corners of the face at about a 45 degree angle.

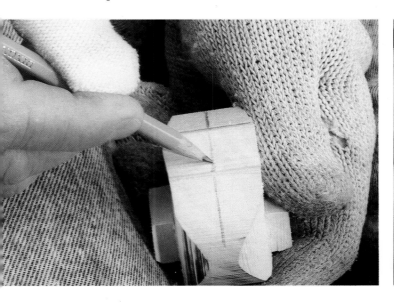

Before I go further I need to add the center line. Actually I usually do this at the very beginning.

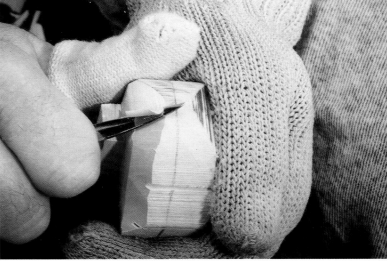

Continue the cut to the top of the head.

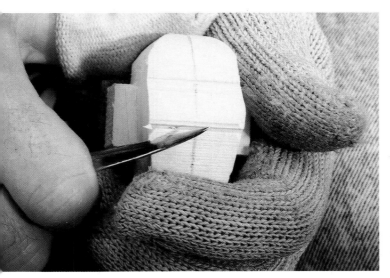

Starting just below the nose...

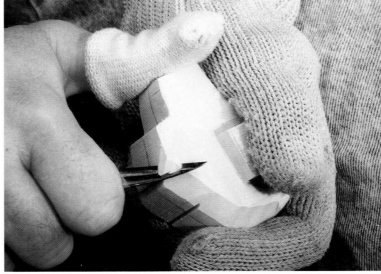

Start just at the top of the nostril...

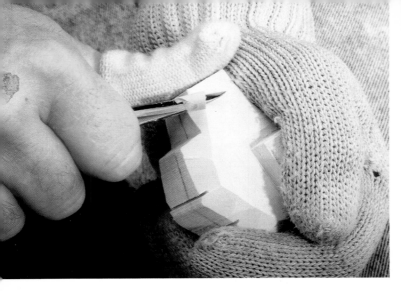

and continue the bevel cut down through the neck.

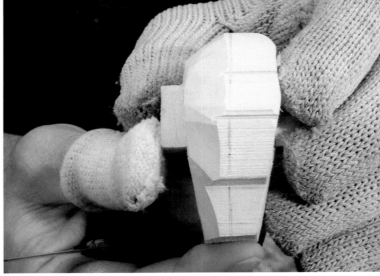

One side done.

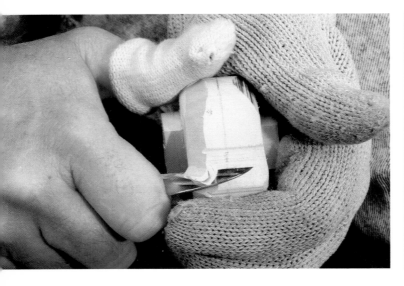

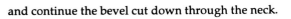

Repeat the same cuts, taking the bevel cut deeper toward the center line.

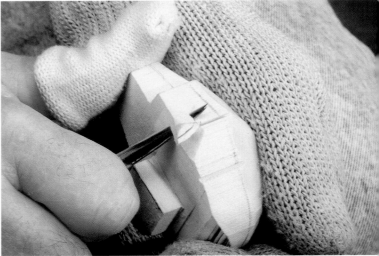

Repeat on the other side.

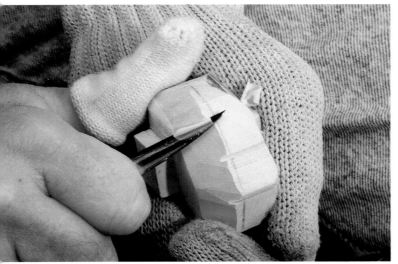

Repeat again until you come to about 1/16" from the center line.

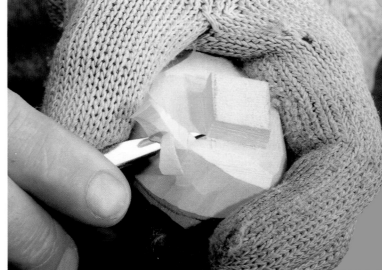

Round the flat area in front of the ear. To avoid the ear, cut this way going up to...

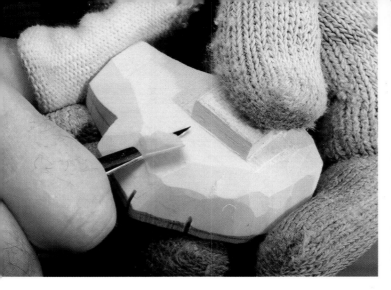

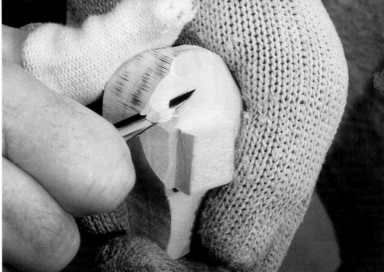

and this way going down.

Round off the back of the head. This shouldn't be as sharp as the front, as you can tell by feeling the back of your own head.

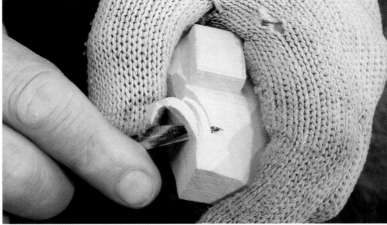

Continue into the neck and repeat on the other side of the center line.

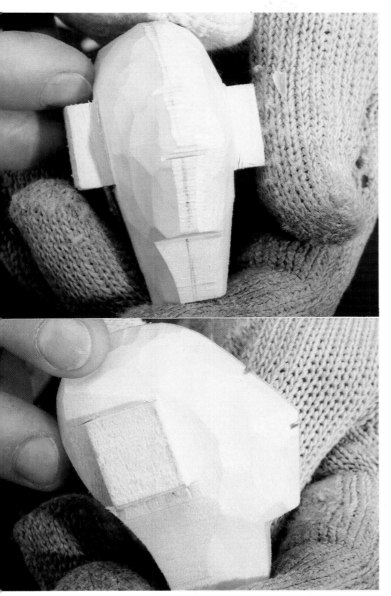

Progress.

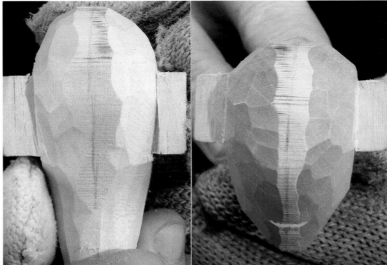

The result.

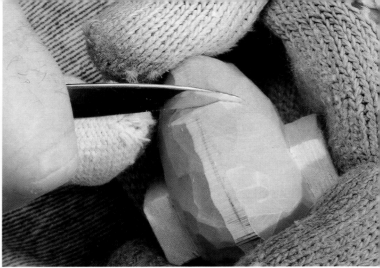

Next we rough in the profile. Begin at the bridge of the nose and work your knife into the line you made earlier with the band saw. For a head this size I want to go about 3/16" to 1/4" deep.

Cut into the same line and carry the stop around to the sides of the head.

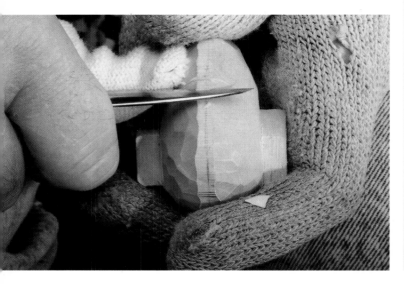

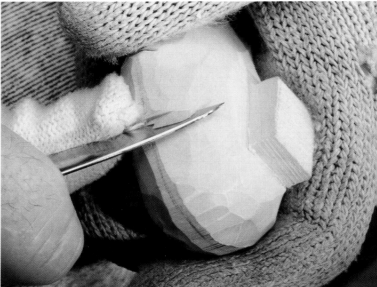

Cut back to the line from the brow...

Cut back to it from the brow again.

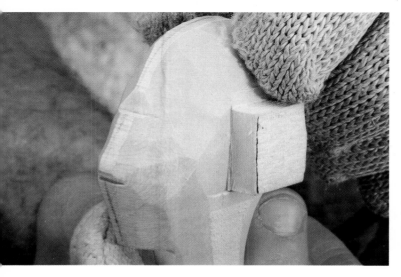

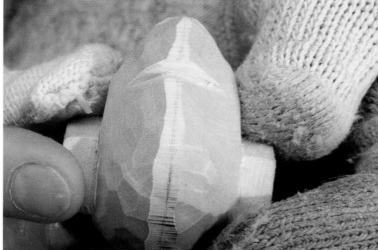

for this result.

The line begins to curve naturally around the head.

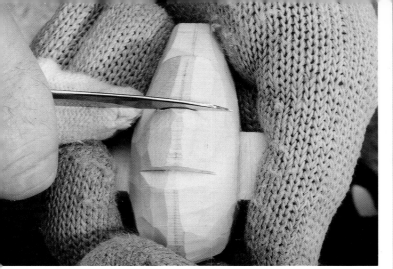

Cut a stop at the bottom of the nose. This is a little deeper, about 3/8". This is a spot where a beginner can get cut, so be careful.

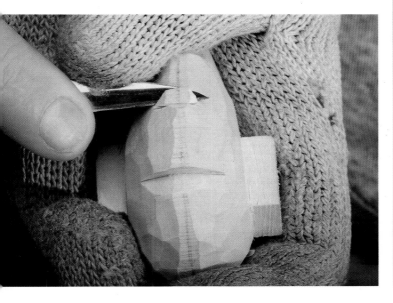

Cut up lightly from the lip. The knife can slip here, popping off the nose and going into your forefinger!

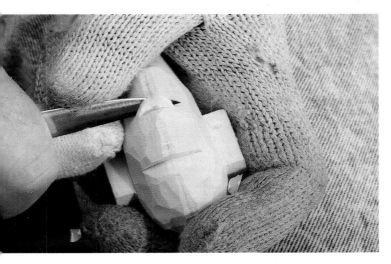

Repeat the process until you get to the desired depth.

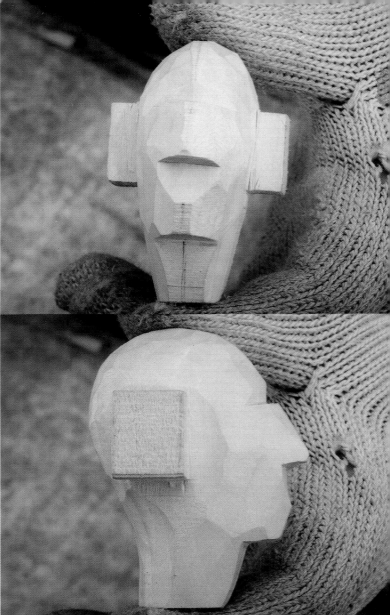

The result.

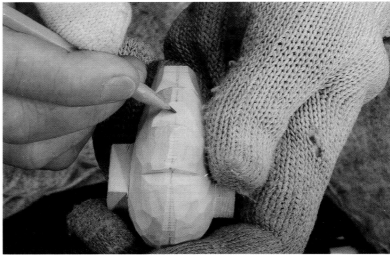

Reestablish the center line.

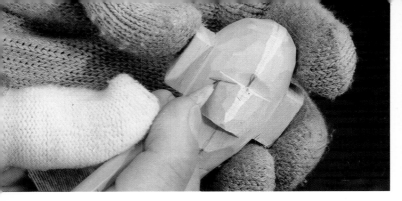

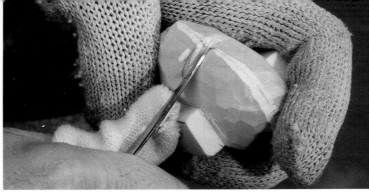

I make a cut following this line, from the bridge of the nose to the outside corner of the eye. The eye slants slightly down to the corner of the eye.

on the other side.

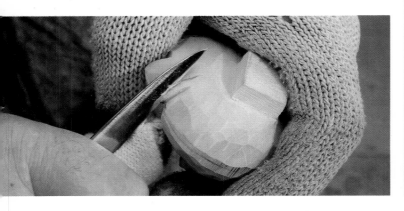

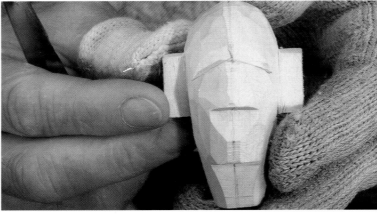

Cut straight into this line...

The result.

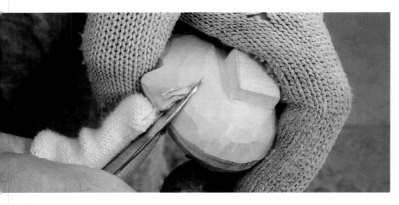

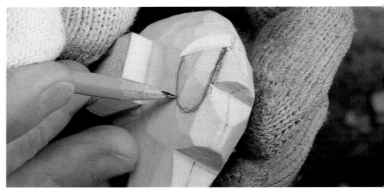

then cut back to it from the notch you already cut in the brow line.

The area beside the nose and mouth, marked in pencil, needs to be removed. This will bring out the nose and mouth mound. The same needs to be done on the other side.

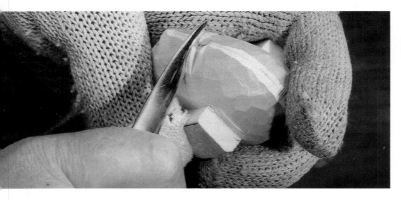

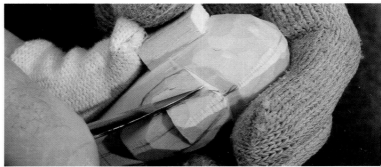

Repeat...

Start at the nose and use a scoop cut...

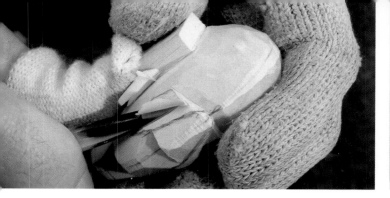

to remove this area.

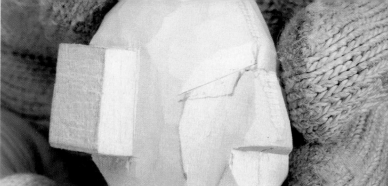

The line for the eye comes down the side of the nose and angles out to the corner of the eye.

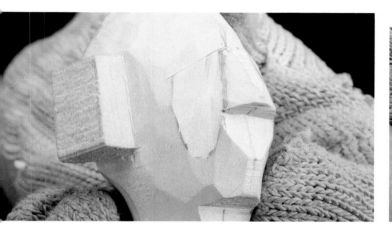

One side done.

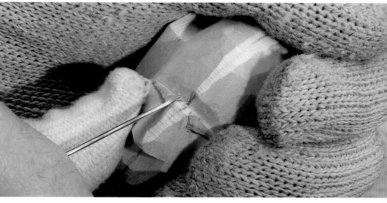

Cut a stop on this line, first coming down the side of the nose...

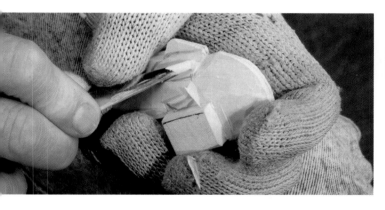

Repeat on the other side.

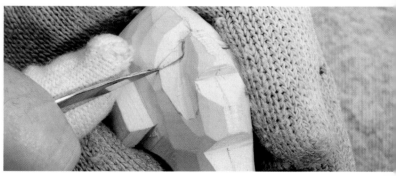

and out to the corner.

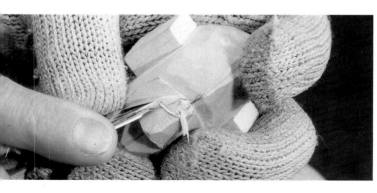

Shape the area where the nose meets the cheek. This smooths up the ridge left by the previous cut at the same time it gives some shape to the nose.

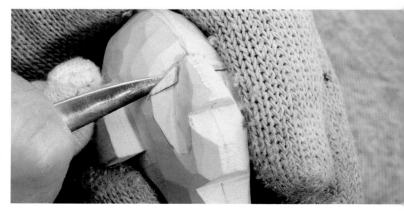

Continue the surface of the eye area into this stop.

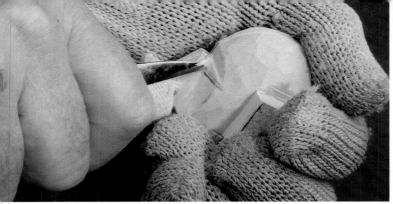

Repeat on the other side.

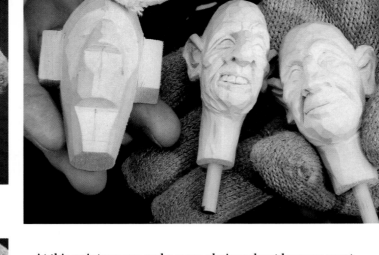

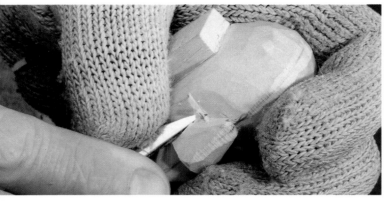

Bevel the ridges left by the previous cut.

At this point we can make some choices about how we want the face to look. Using the same blank I can get a variety of moods, including this grin and this toothy smile.

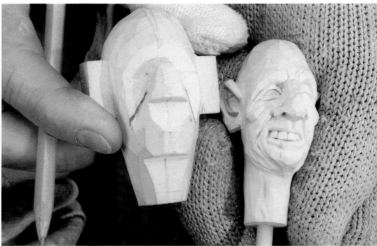

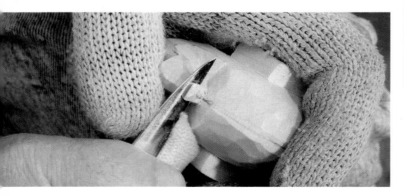

Shape the nose back into the bridge of the nose.

The main mood setter is the "expression" line, the line that goes along the lower edge of the cheek. On the toothy face one expression line goes down and the other goes back, making the mouth a little off-center and giving it a look of talking out of the side of the mouth.

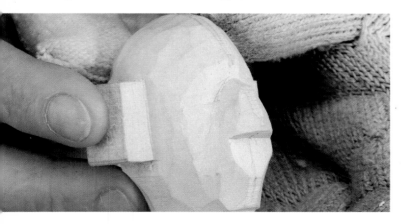

Progress.

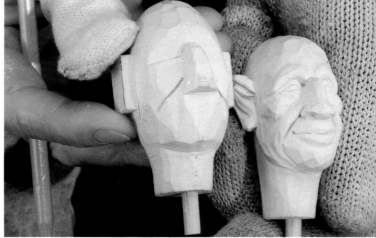

On the smiling face, both lines go down in the same angle.

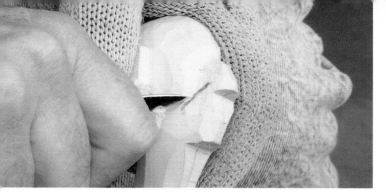

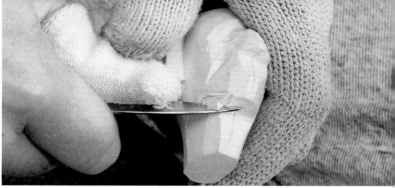

For this book we will do the toothy smile, because it is a little more challenging and better for teaching. To begin, make a cut straight in from the top of the expression line to the bottom.

Cut back to the jaw from the neck. Repeat on the other side.

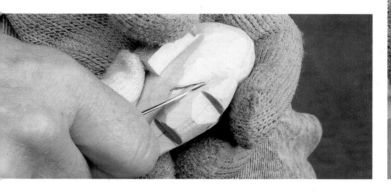

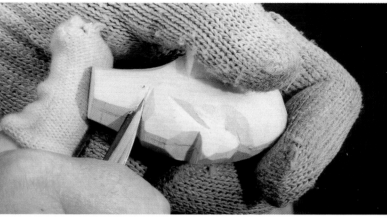

Come back to the line with a slicing cut and removing a wedge.

Shape the neck area a little.

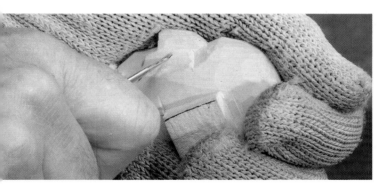

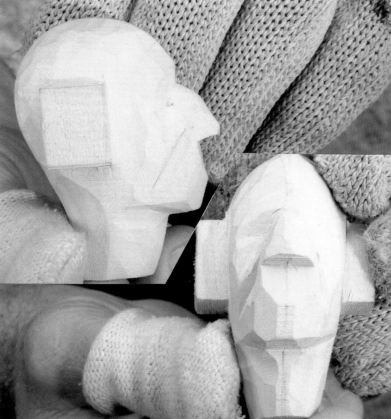

Repeat on the other side.

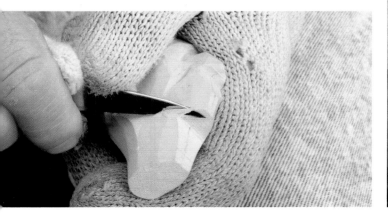

Cut along the jaw line, beveling slightly toward the neck.

Progress.

17

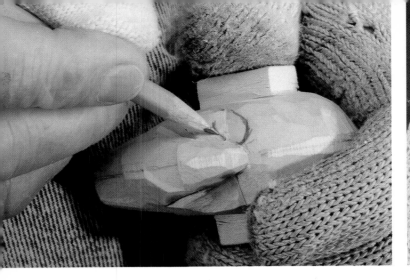

Draw in the eye. The carving technique I use makes the eye smaller, so when I draw it I exaggerate it, making it bigger than I want.

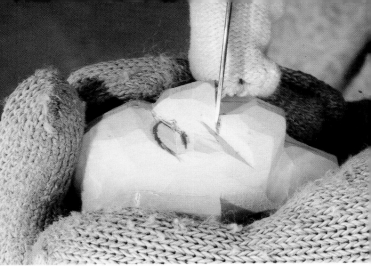

Cut a stop in this line, following the contour of the mouth mound.

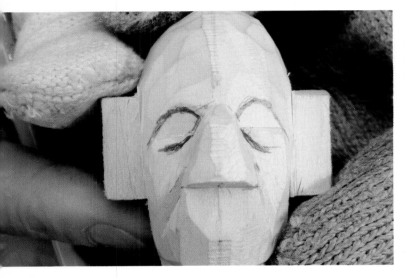

Because the mouth is pulled back on one side, the eye on that side of the face squints a little bit and is smaller.

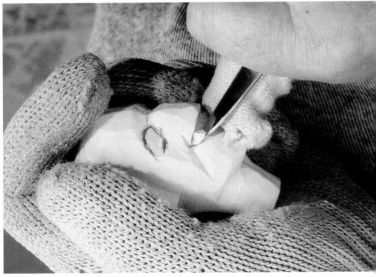

Come back to the stop from the lip.

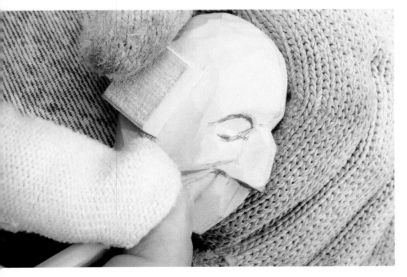

Draw the line of the nostril back to the cheek.

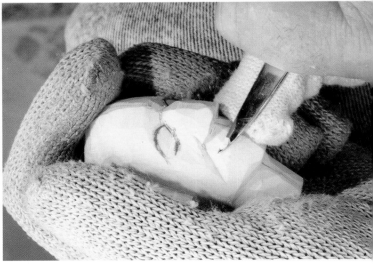

Round up the mouth mound to prepare for drawing in the mouth.

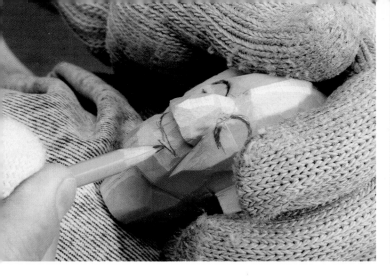

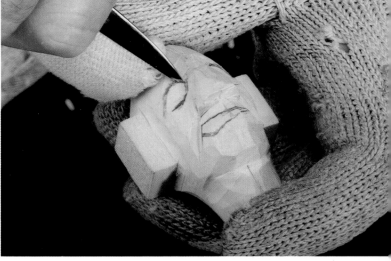

Draw in the mouth.

The cut around the eye with the knife slanting away from the center. Start at the nose....

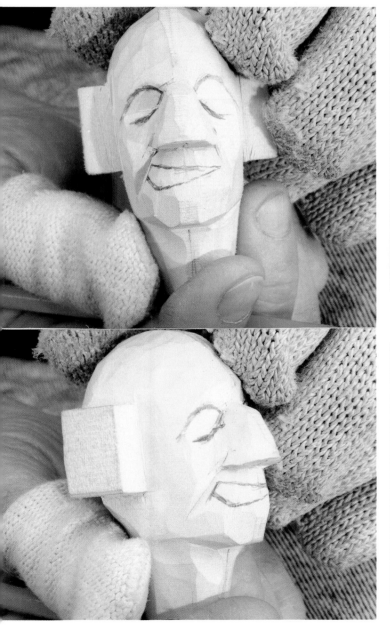

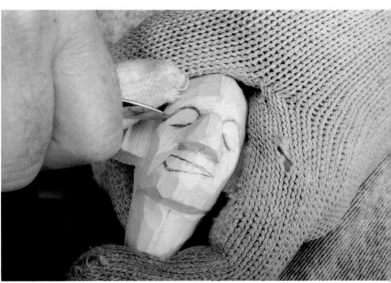

and continue to the outside of the top line.

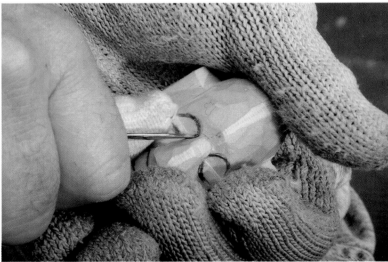

Progress.

Do the same on the lower line, from the inside to the outside...

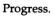

19

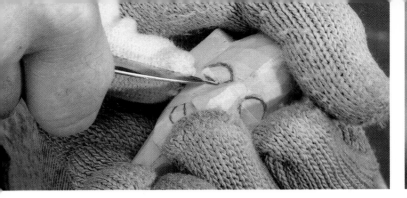

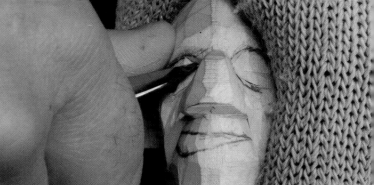

with the knife slanting away from the center. Repeat on the other side.

Along the top of the eye ball I cut back into the top line, rounding the eye ball mound. This is done with a series of three cuts.

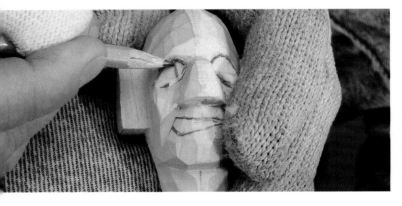

I draw a line about one third of the way from the inside corner...

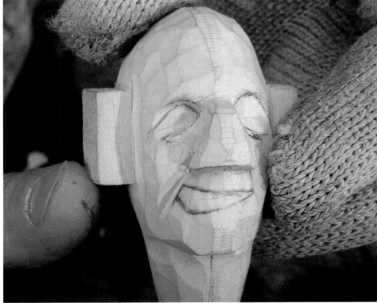

The result.

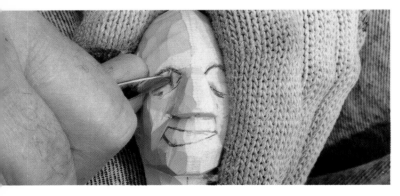

and cut along this line with the point of my knife back in the corner.

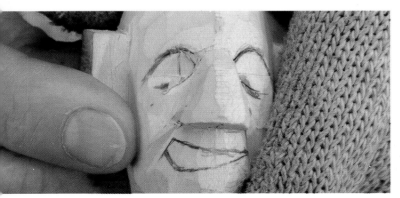

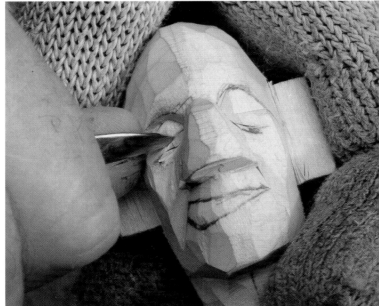

This pops out a wedge in the inside of the eye.

Do the same along the bottom line.

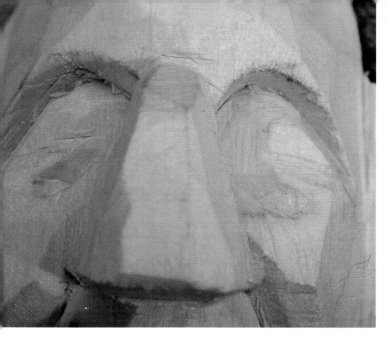

Repeat on the other side.

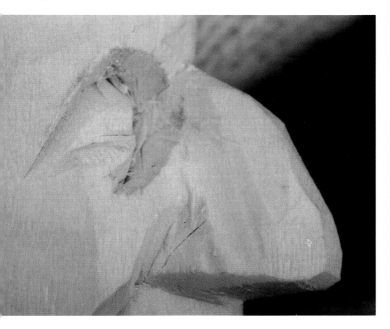

This roughly rounds the eye mounds.

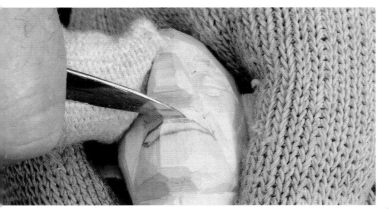

Cut a stop in the top line of the mouth.

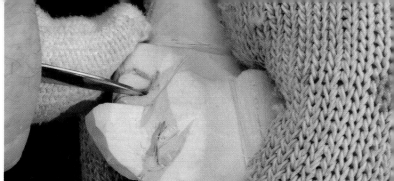

At the exaggerated corner go deeper, because you will be removing a wedge later.

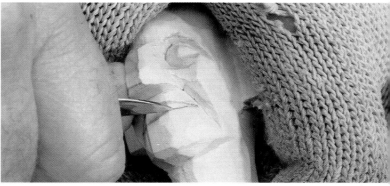

Do the same on the bottom.

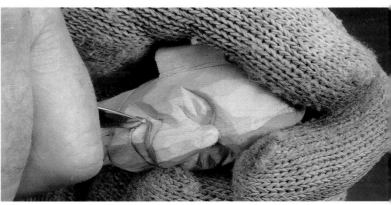

Again, go deep in the exaggerated corner.

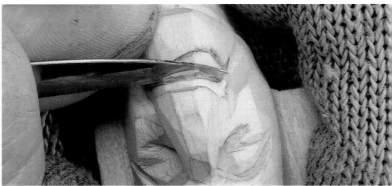

Cut back to the stop at the top of the mouth, recessing the surface of the teeth so they seem to go behind the lip.

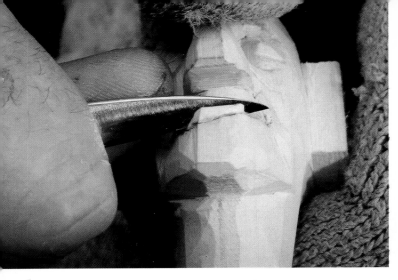

Do the same coming down to the bottom lip.

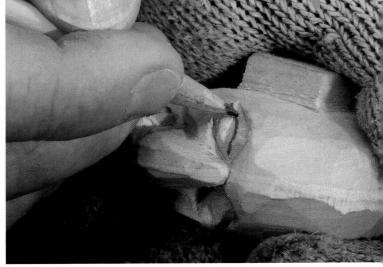

Draw in the upper and lower eyelids.

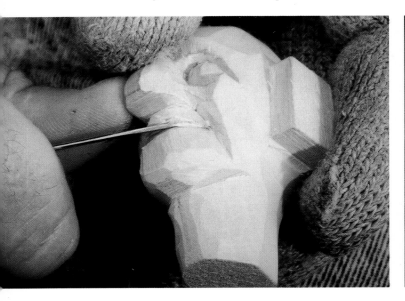

Repeat the process until you get to the proper depth.

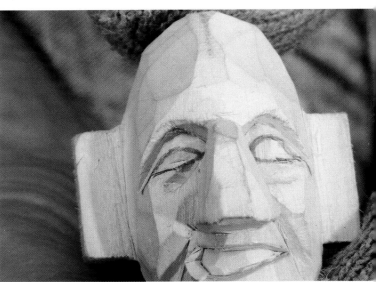

You can see that the sneer-side eye is slightly smaller because it is squinting.

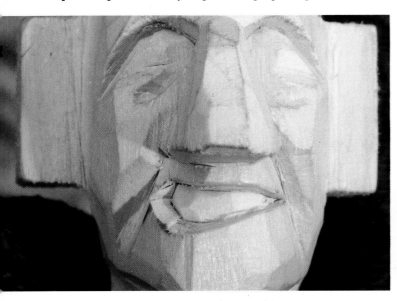

The result. You can see how much deeper the cut is on the sneered side. The teeth come right around.

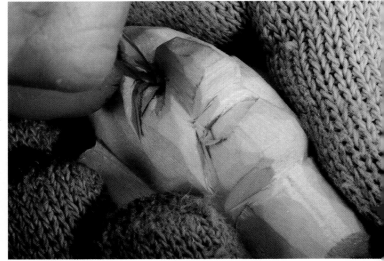

Cut straight in to the eyelid lines. Be really careful or you will slip. Have a sharp, sharp knife and use light pressure.

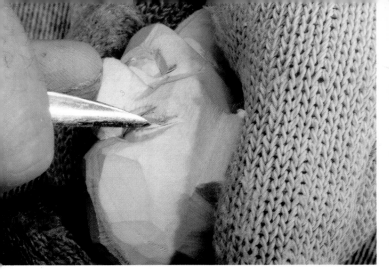

Push your knife into the corner of the eye and cut out a tiny wedge. Repeat at each corner, inside and out.

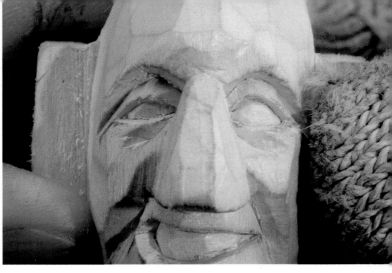

The result.

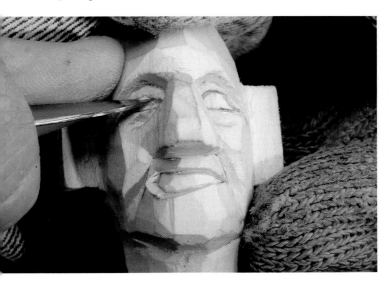

Cut along the surface of the eyeball to bring it under the eyelid, top...

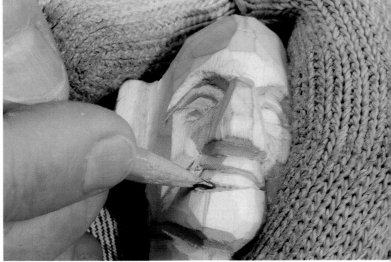

Draw in the bottom of the teeth.

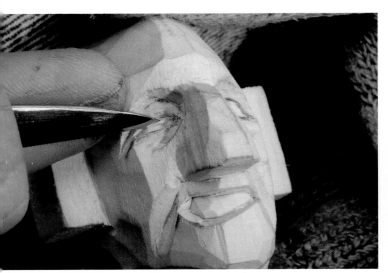

and bottom.

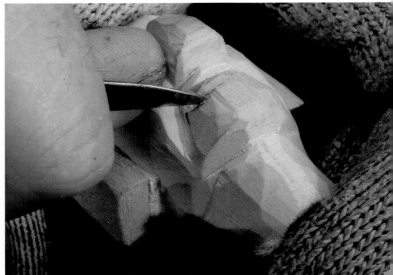

Cut along the pencil line with the tip of the knife, going real deep.

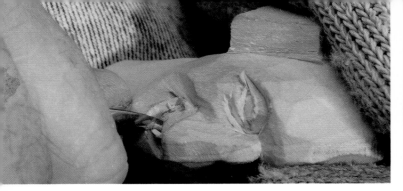

Cut back from the lower lip, taking the wood out underneath the teeth.

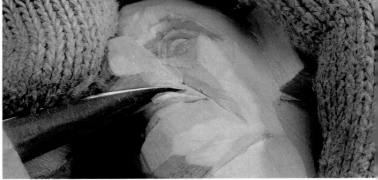

Round the upper lip.

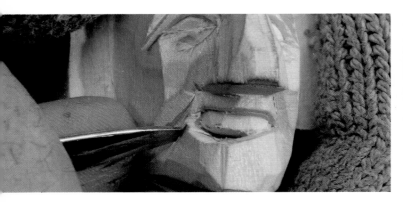

Cut down beside the lower lip, making a stop. Here you can see the result of the teeth cut.

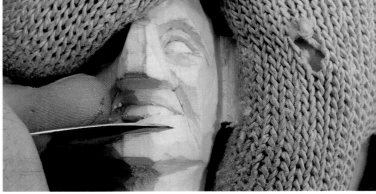

Bring out the bottom lip and chin by coming down beneath the lip...

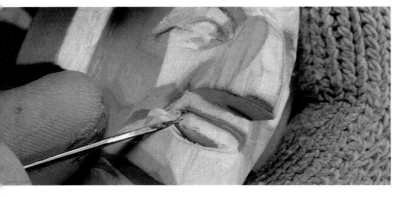

Cut back to the stop along the surface of the lower lip.

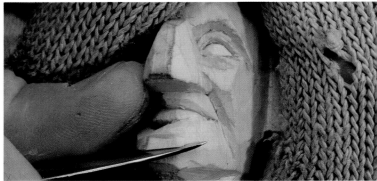

and up over the chin to pop out a wedge.

Round the surface of the lower lip, taking away the sharpness.

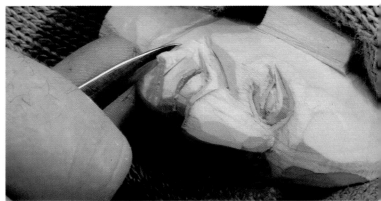

Continue the process around the sides of the chin.

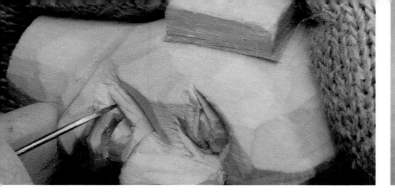

Go right into the corner of the lower lip cutting down beside the character line...

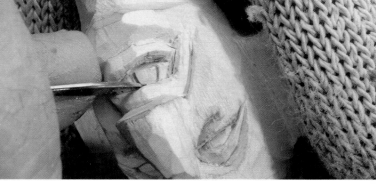

Cut across the line at the gums, going into both teeth to "cross the T".

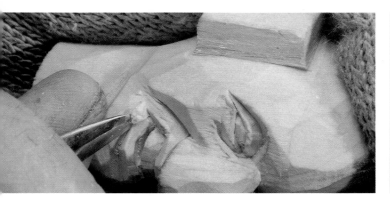

and back to it from the chin.

From there, cut down the edge of one tooth...

Starting at the center, draw in the teeth. For caricatures, my theory is that a few large teeth is better thana lot of small teeth.

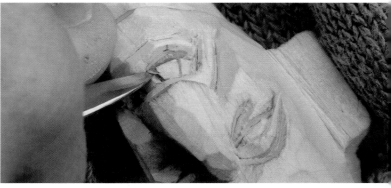

then the other...

Cut a stop in the center tooth line.

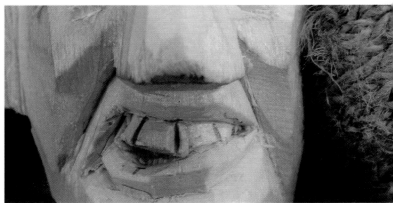

creating a gap like this.

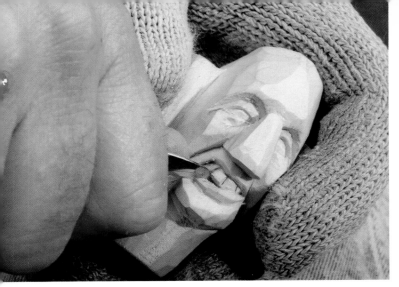

Moving back from the center, cut a stop on a line...

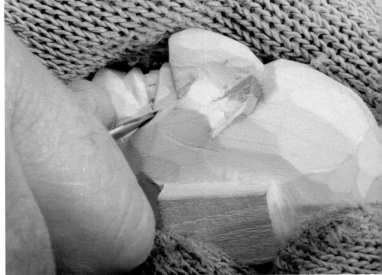

To increase this illusion cut across the corner of the mouth, parallel to the character line.

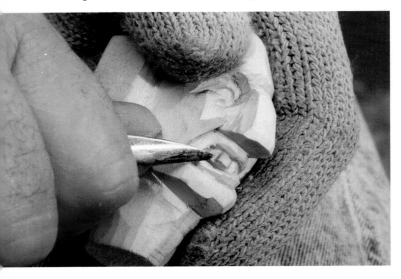

and cut back to it from the tooth behind, making it look as though it is stepped.

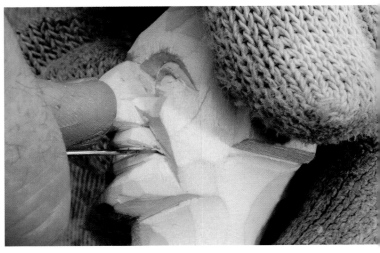

Cut a stop back to the corner along the edge of the lower lip.

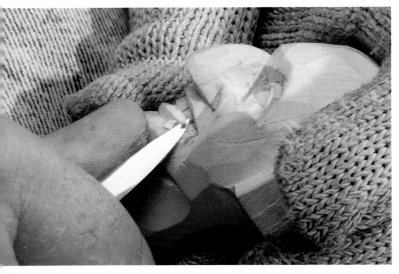

The lower lip needs to look as though it is shorter than the upper lip, so back in the corner, I trim a little away.

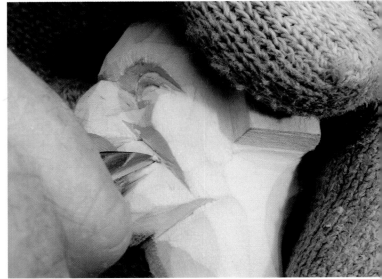

Come back into the intersection of these cuts to remove a wedge.

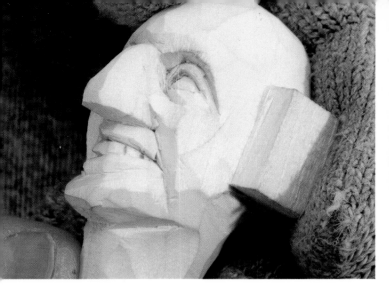

This is the result.

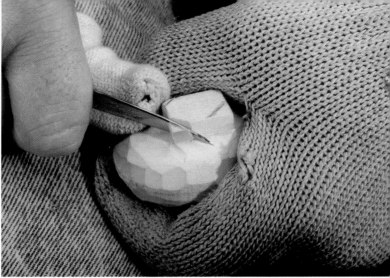

Cut straight into the pencil lines to knock off the corners, down to the head.

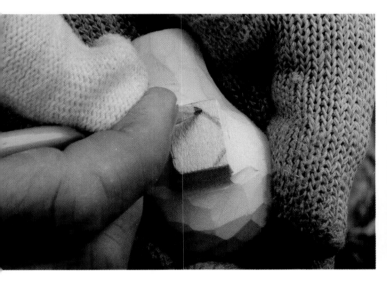

I like to move around the head. This helps me keep things proportional. Now we begin to give some shape to the ears. Draw in the shape of the ear.

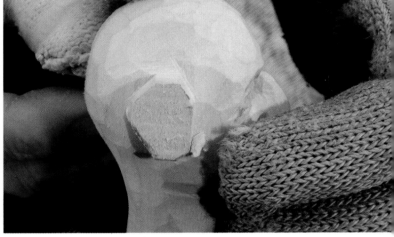

The result.

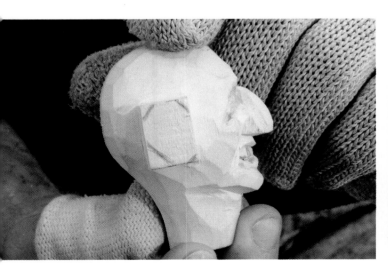

Notice that there is just a small piece to be cut off the earlobe.

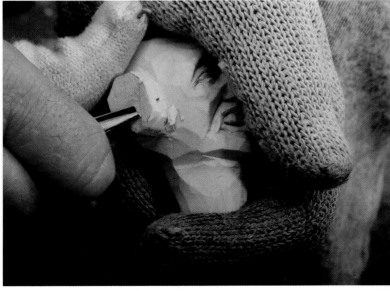

Cut the slant of the ear surface.

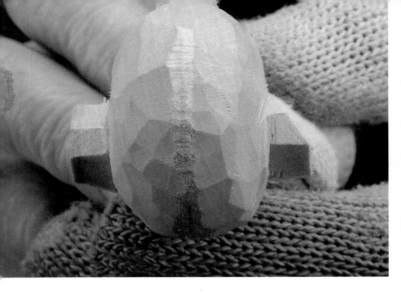

One side done.

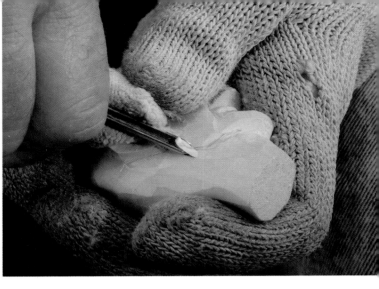

Draw the jaw line and cut it with a #11 gouge.

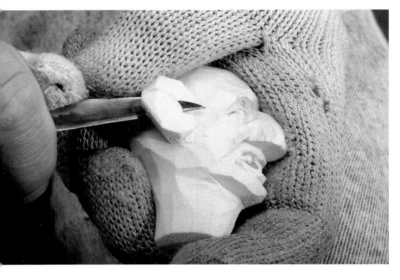

With a swooping cut, give a concave contour to the bottom of the ears.

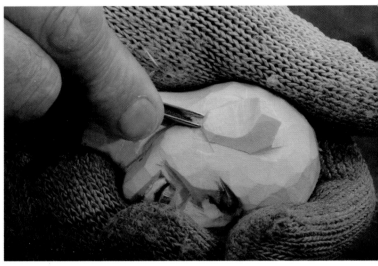

Cut the line nice and easy up to the ear.

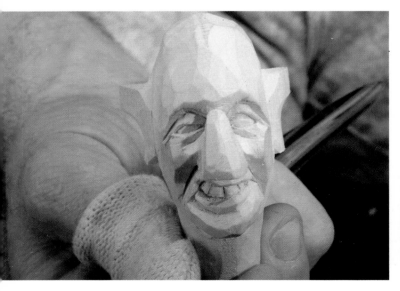

The result.

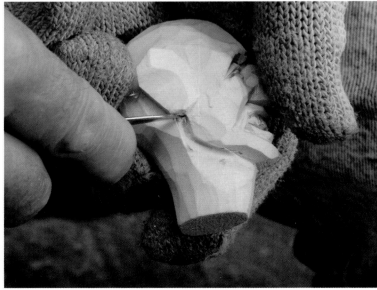

Clip off the end of the cut with a knife.

Smooth the ridge line on the neck that the gouge left behind.

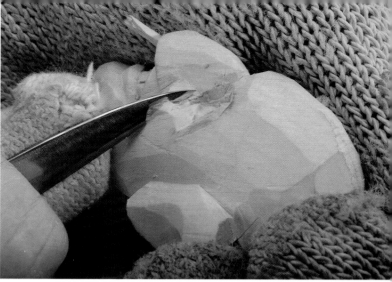

Cut in straight back, going about 3/16" deep.

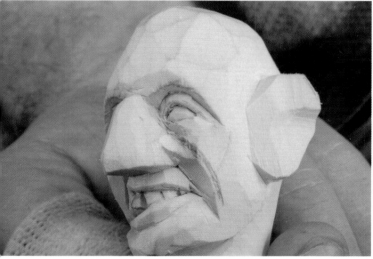

More expression lines need to be added, from the corner of the eyes and running parallel to the main lines. They end in the cheek. This side runs pretty much straight down...

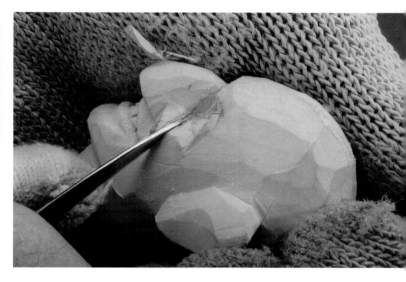

Come back to the first cut with a second slicing cut across the cheek.

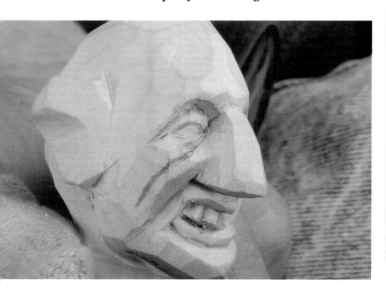

while this side follows the sneering lip.

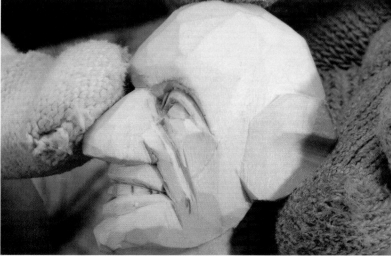

Continue the cut up into the corner of the eye and down to the level of the mouth for this result.

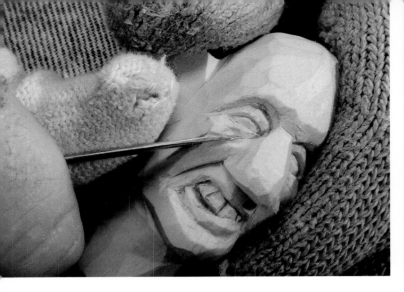

Do the same on the other side.

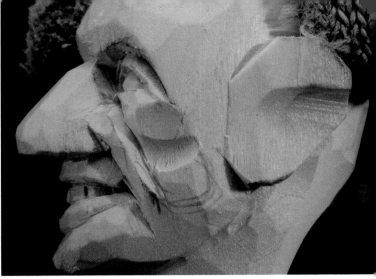

for this result.

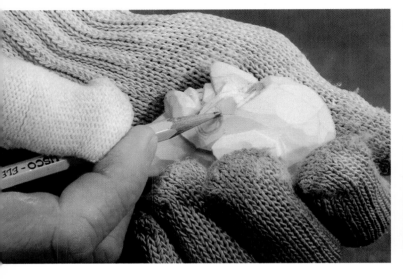

To bring out the cheek bones I remove some of the area beneath them.

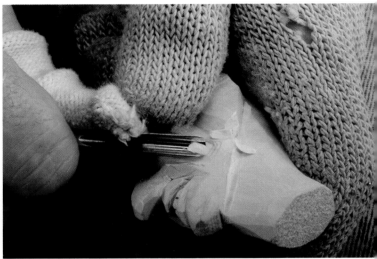

Continue to hollow out the cheek with the gouge, carrying the contour down to the jaw.

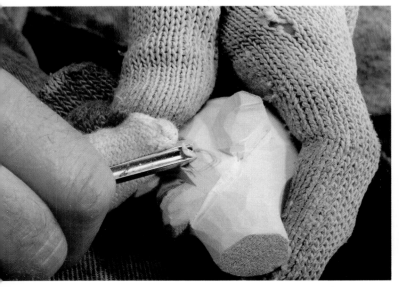

Using a #9 gouge I come across the cheek under the bone...

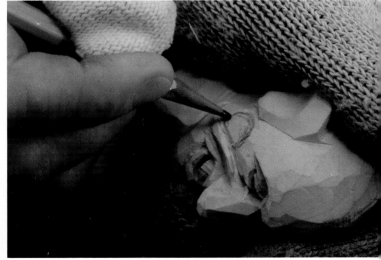

On the sneering side, we need to make the cheek bone a little higher.

30

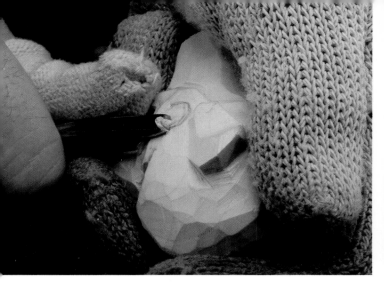

Gouge it out as before.

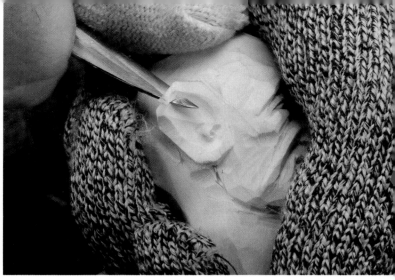

Shape the top edge of the ear.

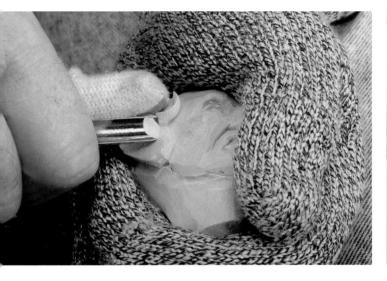

Hollow the ear with a gouge...

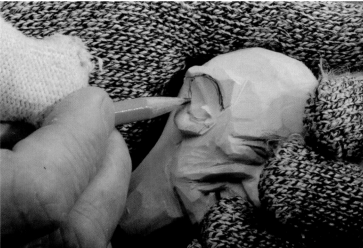

The inside of the ear will be gouged out.

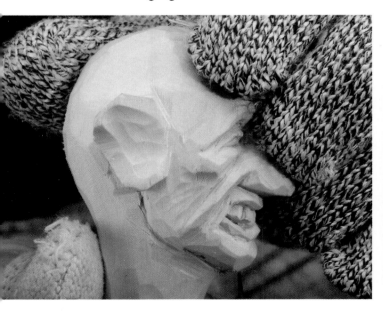

for this result.

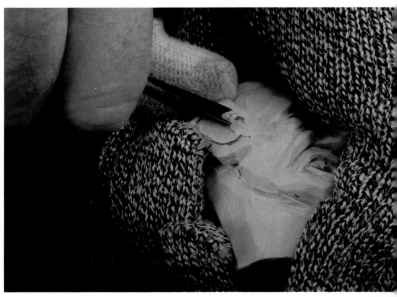

I use a #11 gouge to follow the line of the ear.

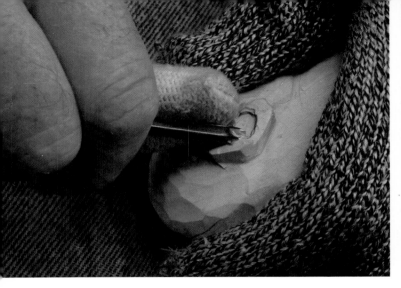

Change direction as dictated by the direction of the grain.

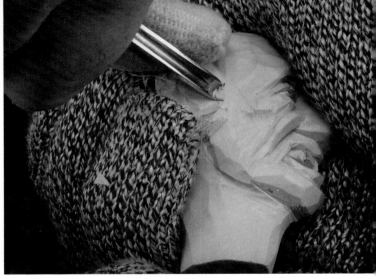

Come back to the mark with the same gouge to relieve it.

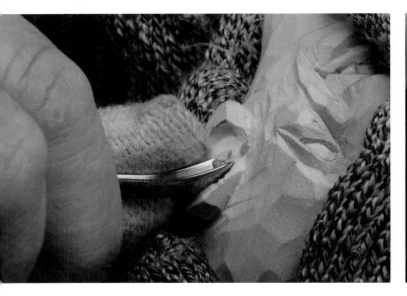

Highlights are added with a v-tool.

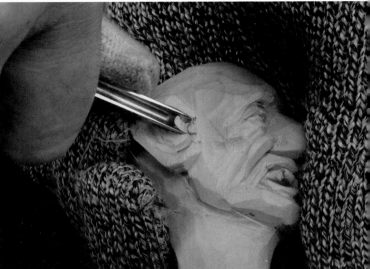

With the same gouge, make a groove in the ear. Repeat on the other side.

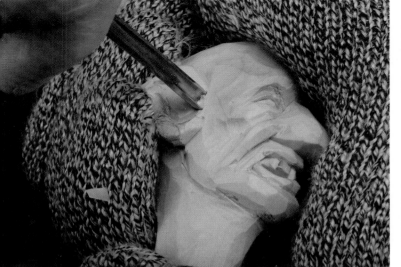

The little flap at the front of the ear is set with a gouge.

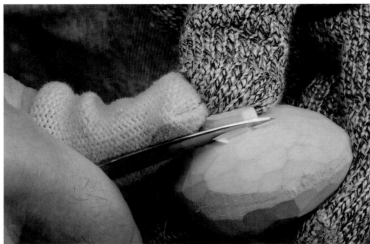

Undercut the back of the ear from the top to the earlobe. Cut along the surface of the ear...

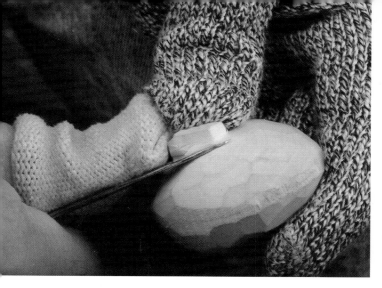

then back along the skull, taking out a wedge.

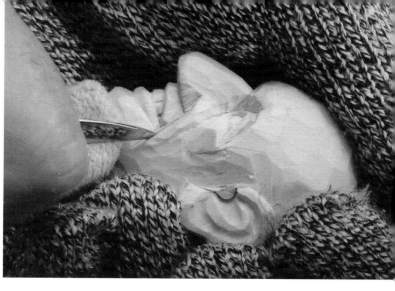

Come down the expression line, deepening the cut...

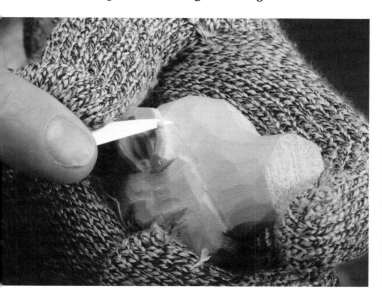

Go back and soften all the sharp edges around the outside of the ear.

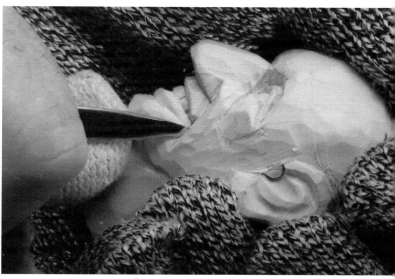

then cut back to it to take out a ridge.

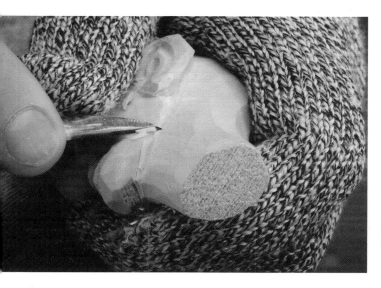

Go back and clean up the carving.

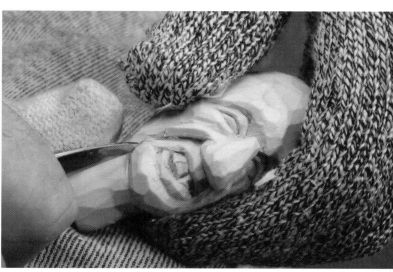

On the sneer side I want to accentuate things by bringing the line down a little further.

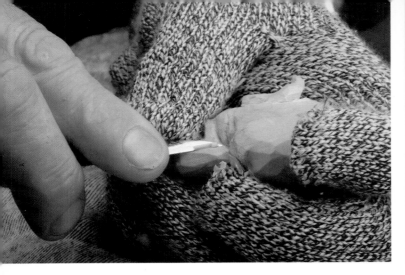

Shape up the nose.

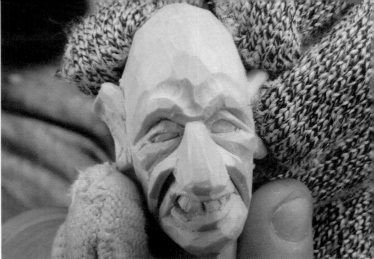

Progress.

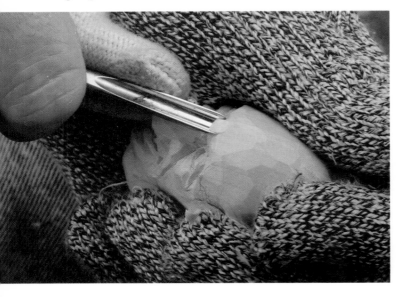

With a gouge divide the brow at the bridge of the nose.

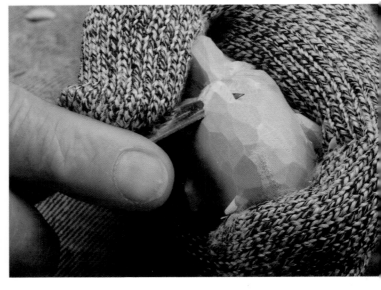

Blend the forehead into the groove above the eyebrows.

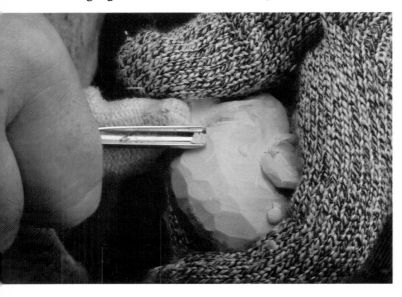

With the same gouge run a groove above the eyebrows, forming their ridge.

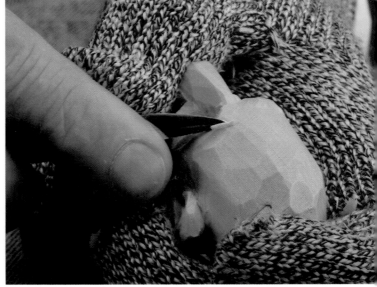

Shape the eyebrow mound.

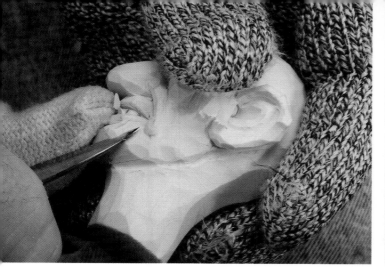

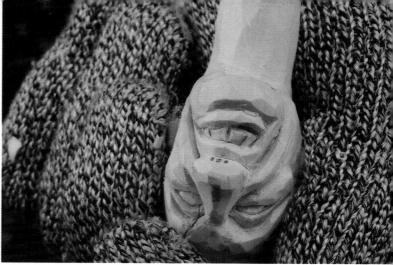

Now is the time for details. The chin needs a little shaping and thinning.

and a guideline to either side.

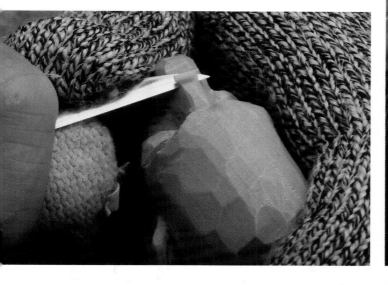

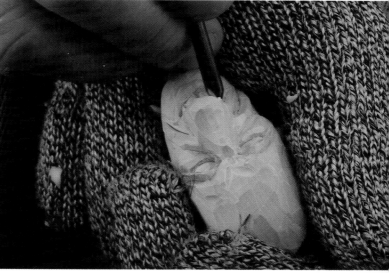

The nose is pretty straightforward and needs a little more character.

I follow the guideline with a #11 gouge, going from the tip of the nose toward the lip.

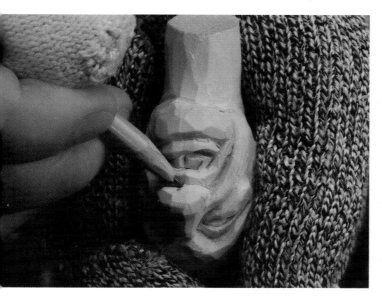

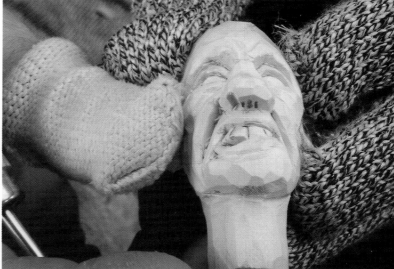

Before cutting the nostrils, I draw a center line...

One side done. Repeat on the other side.

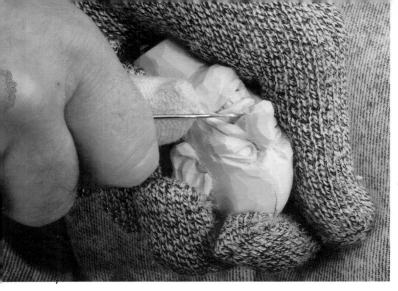

Shape the side of the nostrils.

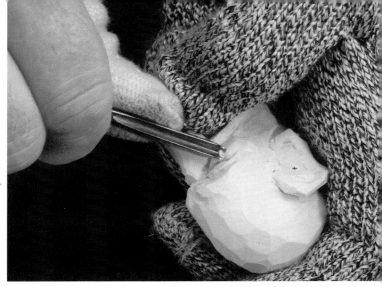

Under the eyes, create sacks with the #11 gouge, working from the nose to the end of the eyelid.

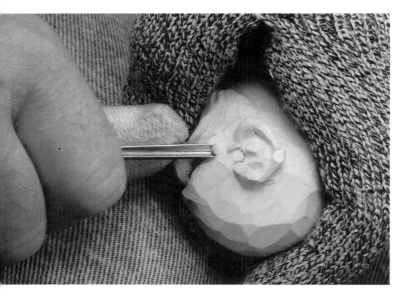

With a small gouge, carry the line of the eye back to the ear.

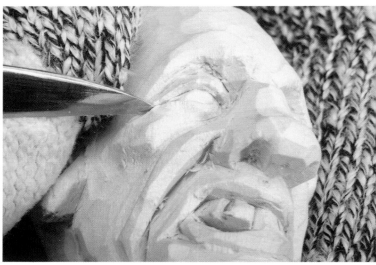

Extend the line of the upper eyelid...

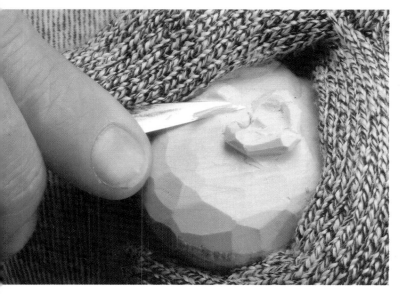

Add some contour to the temple.

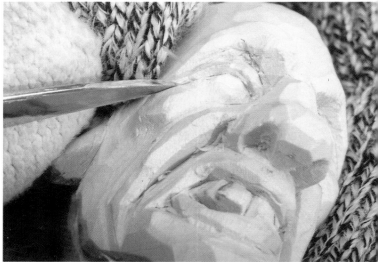

then slice back to it from the lower, giving the impression that the lower lid goes under the upper.

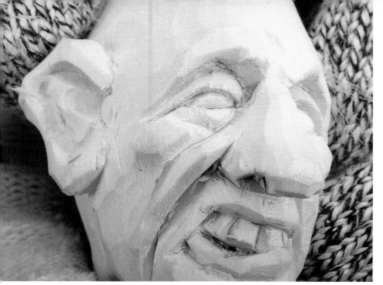

The result.

Remove the resulting ridge from the forehead.

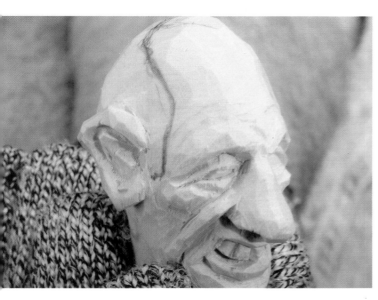

Draw in the hair line.

Reduce the head to bring out the hair.

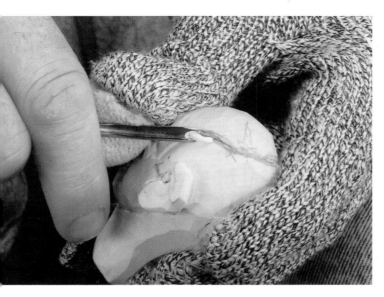

Follow the hairline with a #11 gouge.

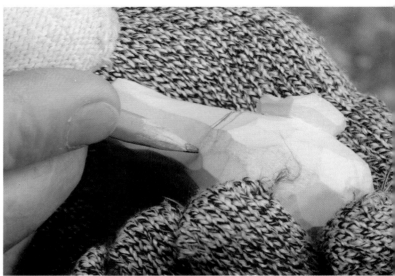

Draw the hairline at the back of the head.

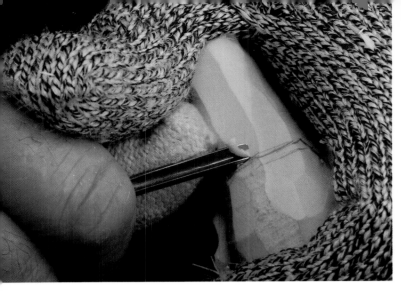

Go over the line with the gouge.

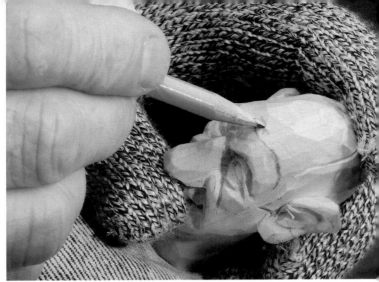

To make the head more interesting I add some random wrinkles. First, draw them in...

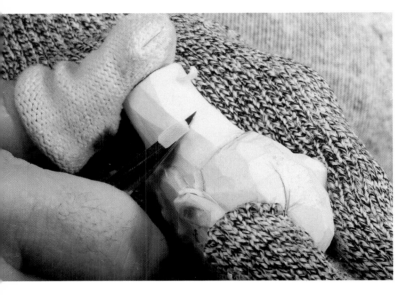

Blend in the neck.

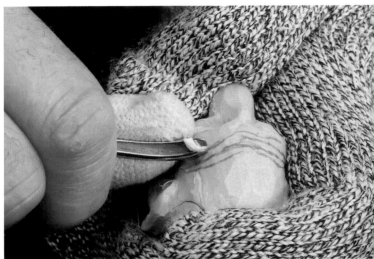

then go over the lines with a v-tool.

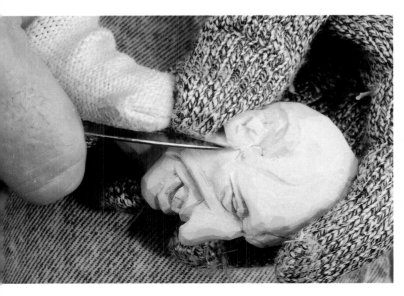

Define the end of the sideburns and clean up around them.

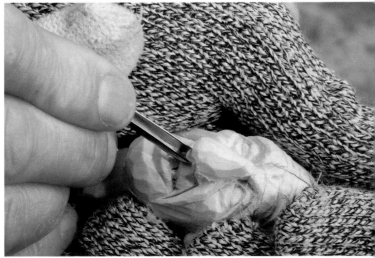

Cut in the philtrum. Because the face is exaggerated I give it a little curve.

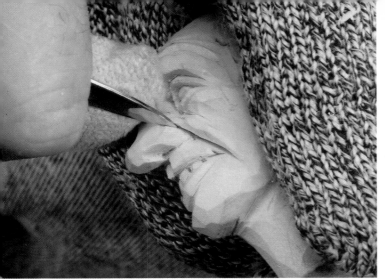

Bring the expression line around to form the flange of the nostril.

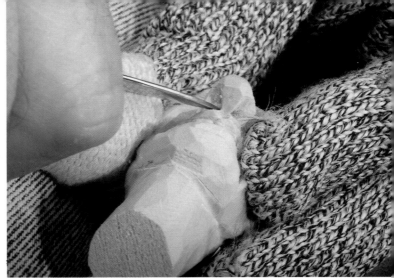

Use the point of the knife to deepen the hole of the nostril.

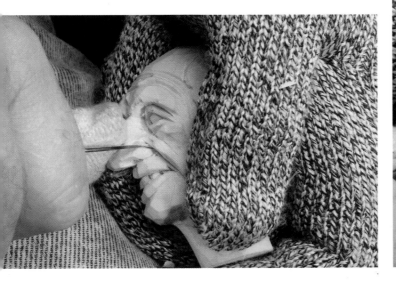

Cut up to the line from the nostril to deepen and clean it out.

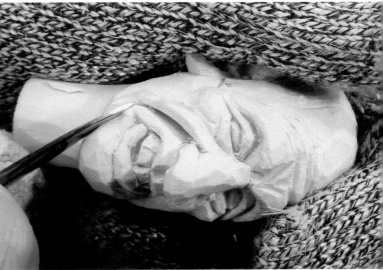

A few cuts break up the flatness of the chin, and give it more character.

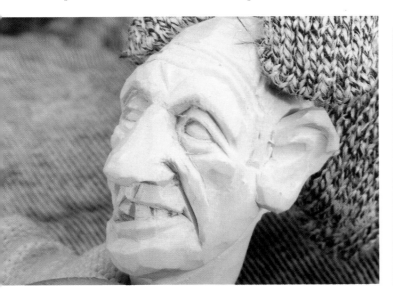

The result.

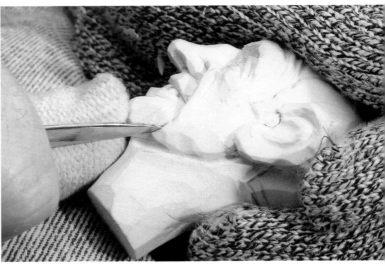

Extend the expression line down further...

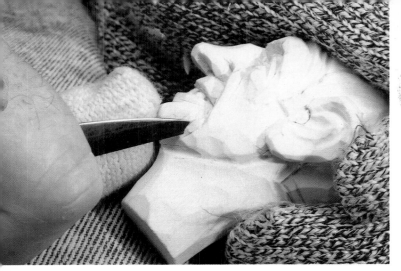

and trim back to it from the chin.

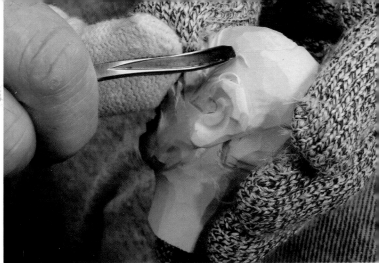

and work my way up.

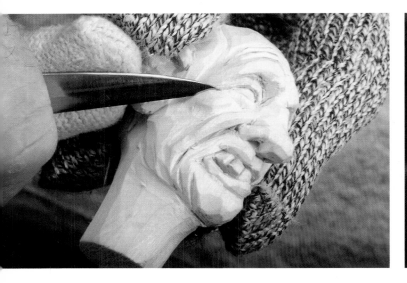

Little wedge cuts with the knife create wrinkles at the corners of the eyes.

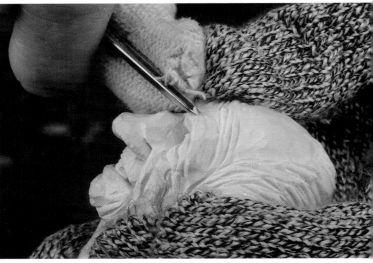

Use a veiner to add hair to the eyebrows. Work from the bridge out, using short strokes.

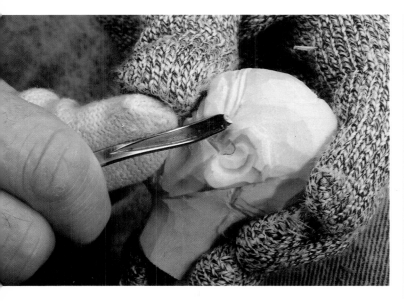

Short strokes with the v-tool create the hair. I start at the side...

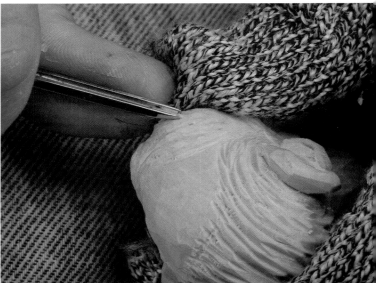

Repeat on the other side.

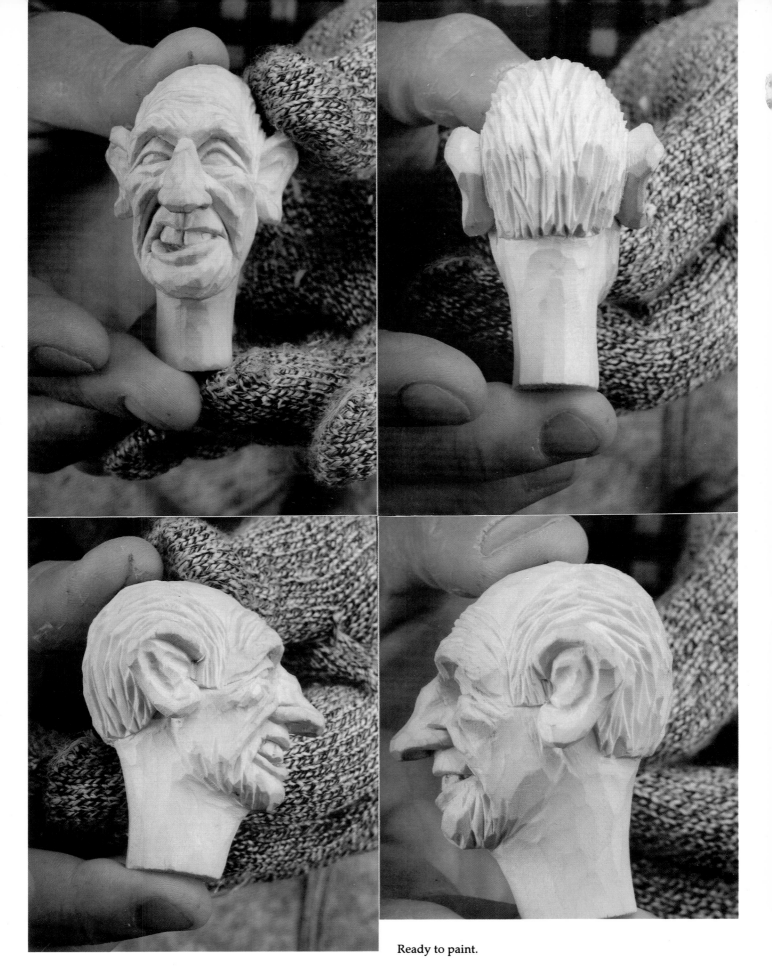

Ready to paint.

Painting the Caricature

For the eyes and teeth I use an acrylic hobby paint, of the type used by stencillers and others. This dries quickly and allows me to continue painting in oils which dry slower. To get an off white I mix a white with a little fleshtone. Using a straight white would be unnatural.

and apply it to the whole eyeball on each side.

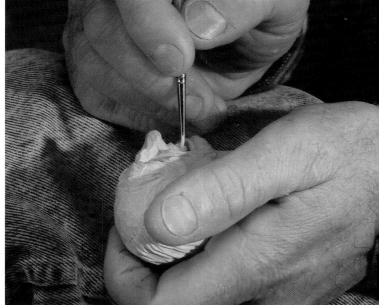

Dilute some of the mixture with water to make it soupy for the first coat...

Continue with the teeth.

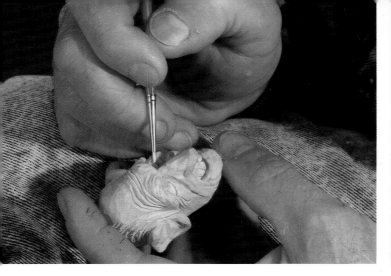

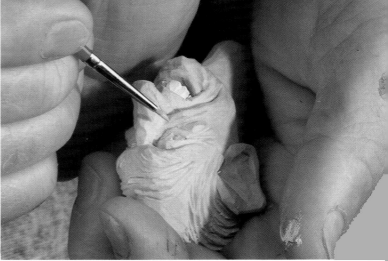

When the first coat has dried, apply a second coat, full strength as it comes from the bottles.

Apply color to the iris. I usually use blue or a blue-green mixture. This is full-strength acrylic. Repeat on the other eye. On caricatures, you never want the figures looking straight ahead...they look like zombies. If it is sneering or chomping on a cigar on one side, I have the figure looking to that side. Otherwise I have them looking slightly up, slightly down, or slightly off to either side.

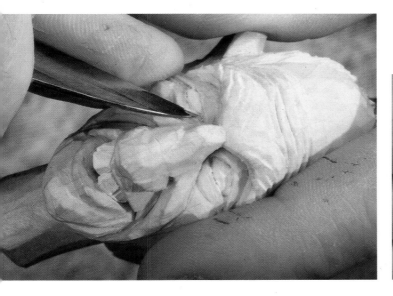

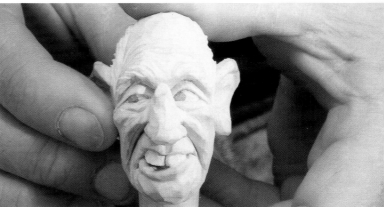

If you get a little white where it doesn't belong, skim it off with the knife.

The iris painted.

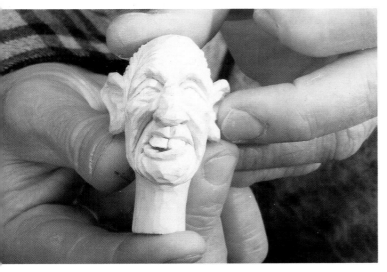

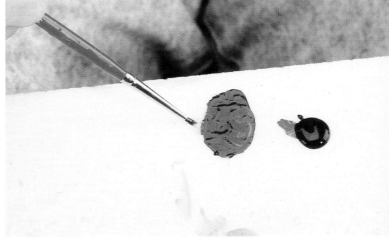

Paint the pupil with a black paint, touched with a little of the iris blue. This touch of blue flattens the black and makes it more realistic.

The white applied.

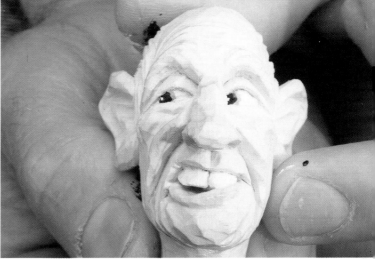

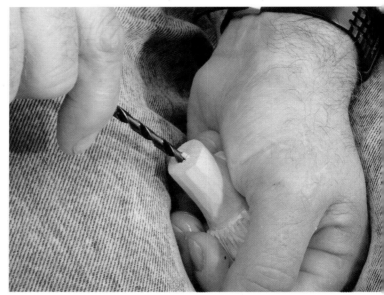

Apply the black mixture to the pupil.

like this. They should be in the same position in each eye.

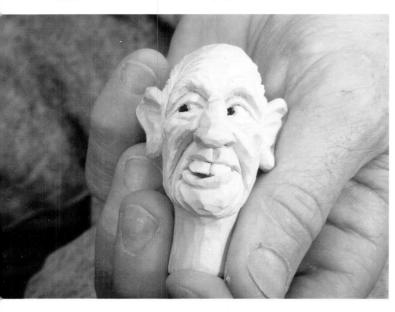

The finished iris and pupil.

Drill a hole in the neck for a 3/16" dowel.

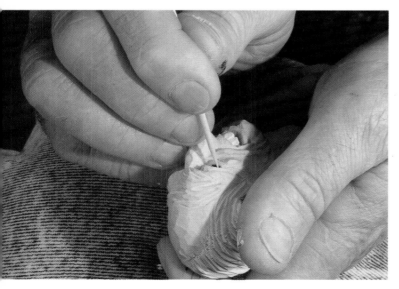

With a toothpick put a white glint in the irises...

I use a mixture of 16 ounces of natural Watco Oil™ and raw sienna artist oils from a tube. I use about a one inch squeeze from tube. After mixing it thoroughly I test it. What I want is a pale yellow color, which looks like this when applied to basswood. **Caution:** Watco Oil™ is a great product, but it is highly inflammable. Improper storage and disposal of oil soaked rags have been linked to several fires. Properly dispose of oil-soaked rags and paper to avoid spontaneous combustion.

44

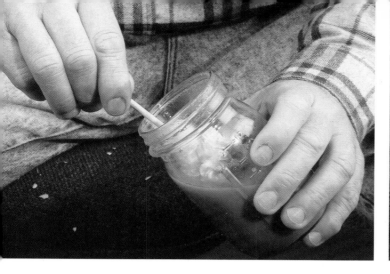

With a dowel inserted in the neck, I simply dunk the head in the Watco Oil™ mixture.

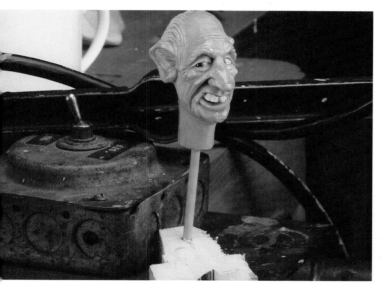

Stick it in a stand and let it sit for a few minutes. Notice that the oil does not obscure the painted areas. The unpainted basswood takes on the coloration of pine.

Dab away any excess.

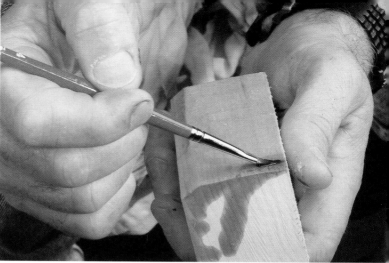

I set up a test board for colors, coating it in the undercoating mixture, and using it to make sure the colors are the correct tone and consistency.

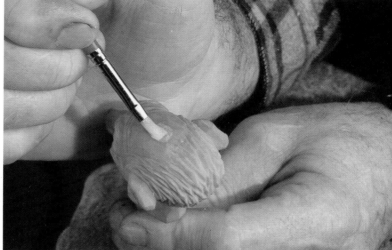

The flesh tone begins mixture of Watco Oil™, zinc white, and a dot Alizarin crimson. This will produce a shocking pink color. To this add burnt sienna a little bit at a time, shaking the bottle and testing on basswood, until you get the skin tone you are after. Apply to all the skin areas.

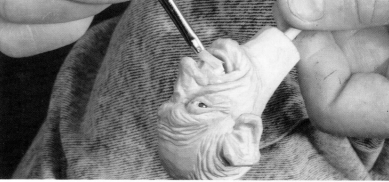

I don't go over the hair areas with the flesh tone, but I do go over the eyes and teeth. When it dries it will not be visible, but the effect will be to soften these features.

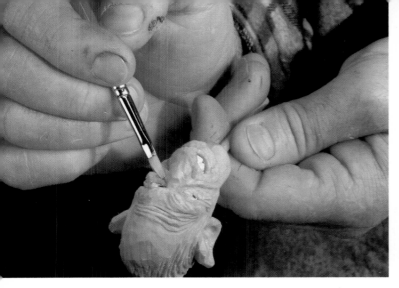

Brush away any excess paint.

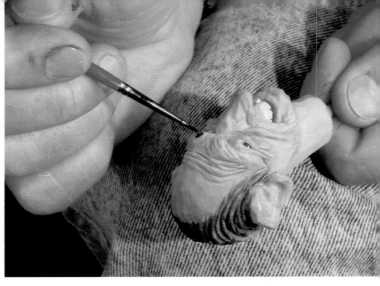

For the eyebrows, I switch to a smaller brush.

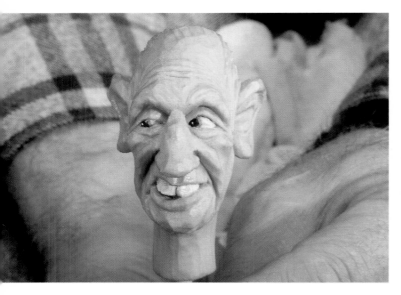

The flesh tones applied.

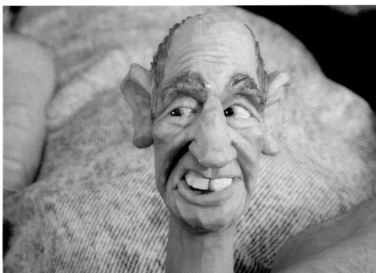

Progress.

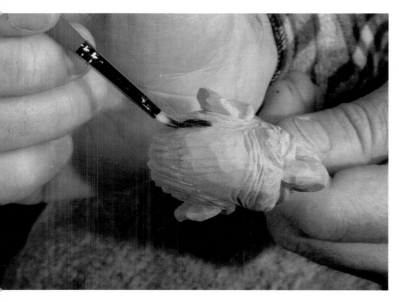

The hair color is a thinned down burnt umber.

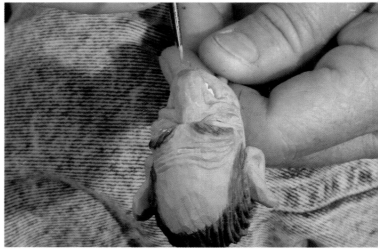

A little tube-red diluted with oil adds color highlights. Wipe the brush on a rag first, then apply a dab to each cheek, the tip of the nose, and the chin.

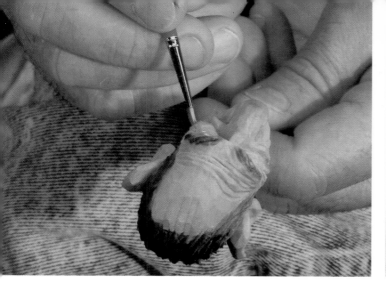

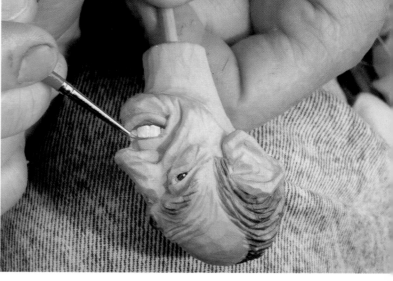

Put a little flesh tone on your brush and use it to blend the red into the face.

The color for the lips is tube red mixed with a little burnt sienna. Be sure to test it first. Do the top lip first...

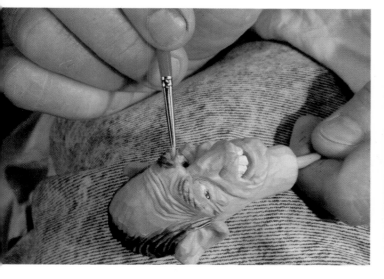

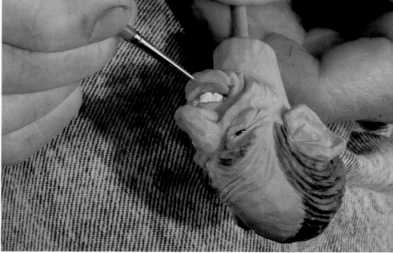

Do the same on the upper lids of the eyes...

then the bottom.

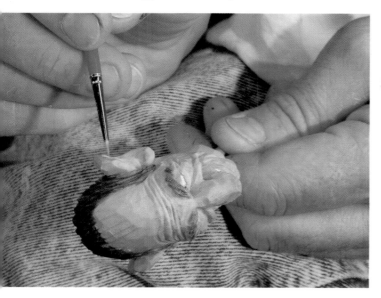

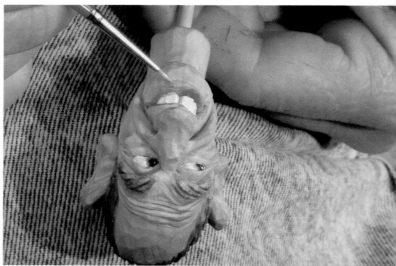

and the top of the ears.

If you get red on the surrounding area, go over it with a clean brush with clear oil. It will come right off.

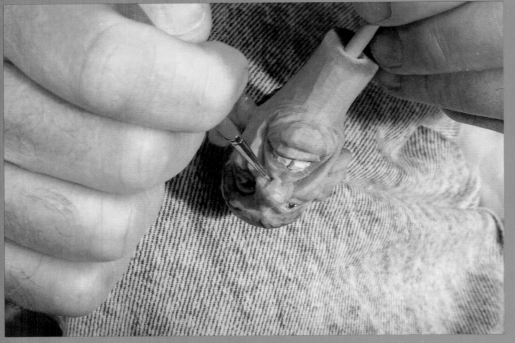

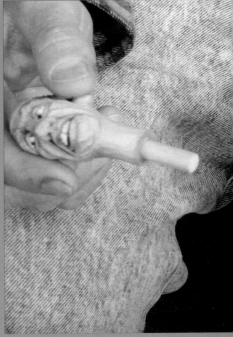

Apply a little burnt sienna to the nostrils to darken them.

Making the figure into a bottle stop is the easiest step, especially if you find a cork with a 3/8" hole already drilled through. Otherwise you will need to drill a hole yourself.

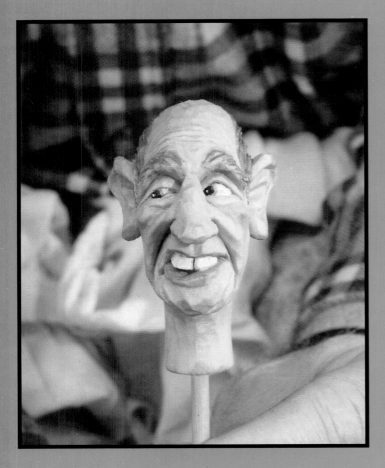

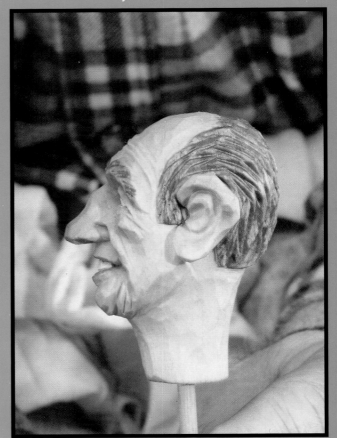

The finish head. In five days I will coat it with a high quality paste wax.

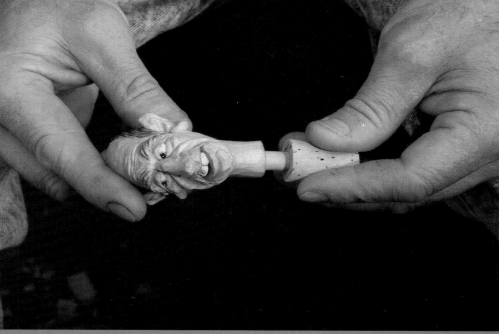

Apply glue to the dowel and insert it in the cork.

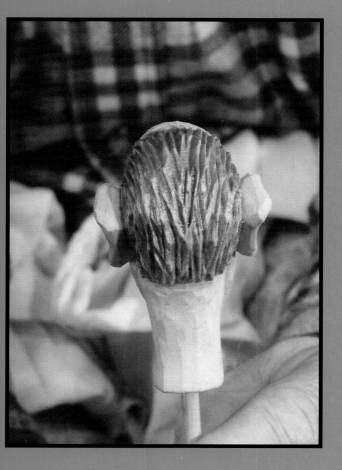
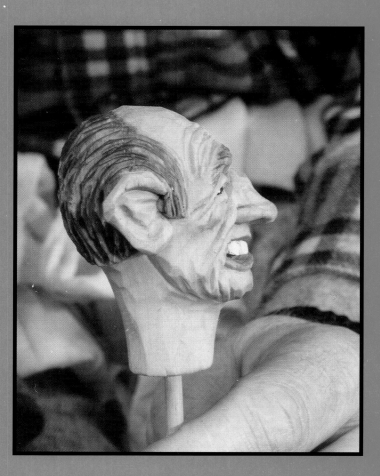

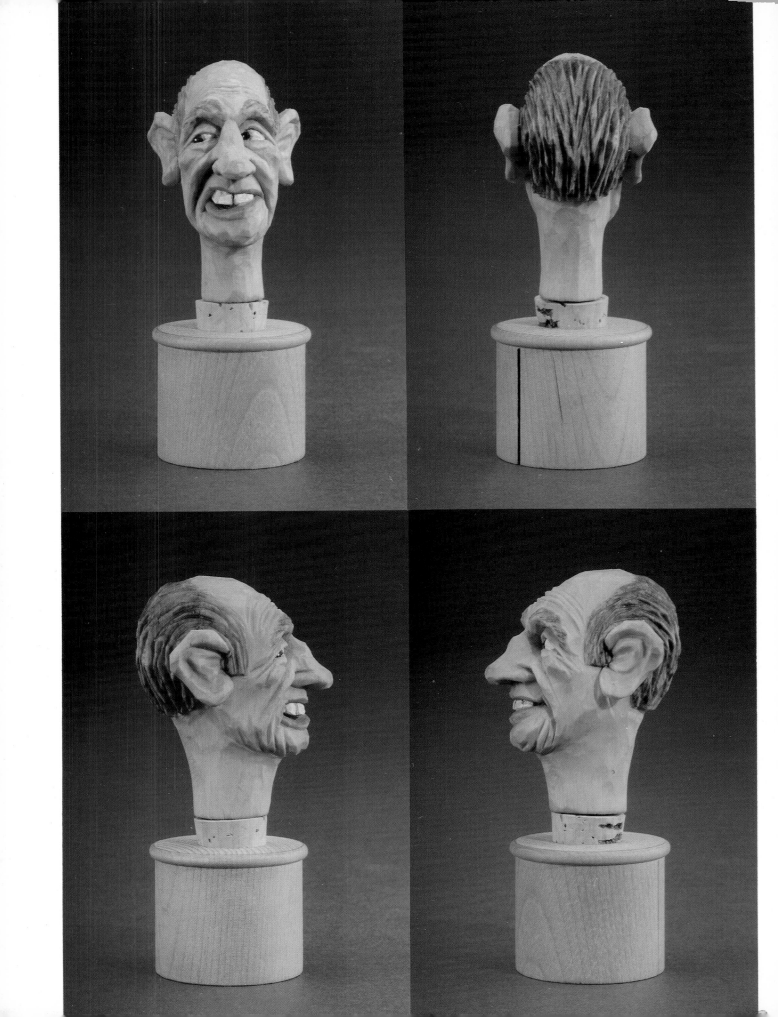

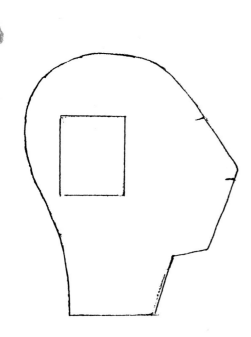

All of these carvings used this pattern.

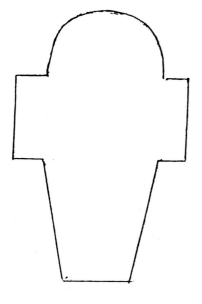

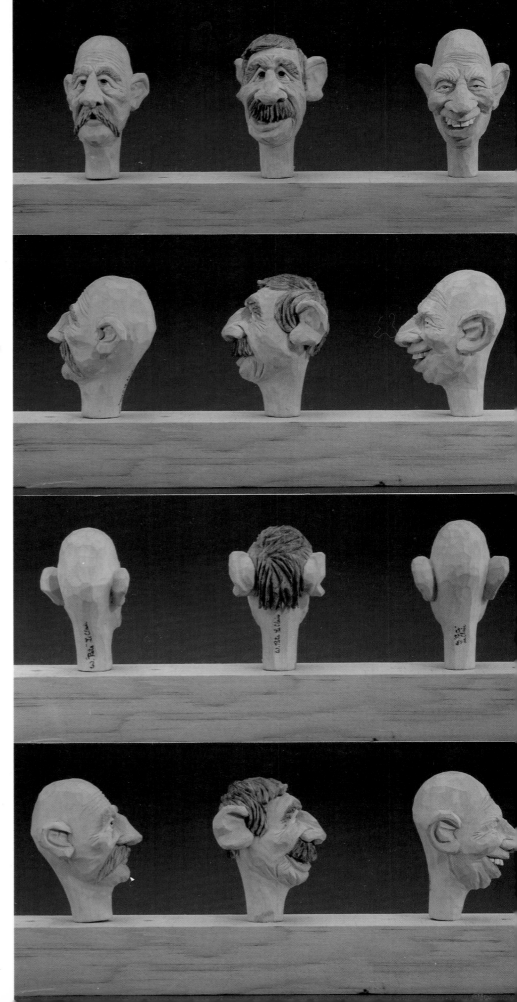

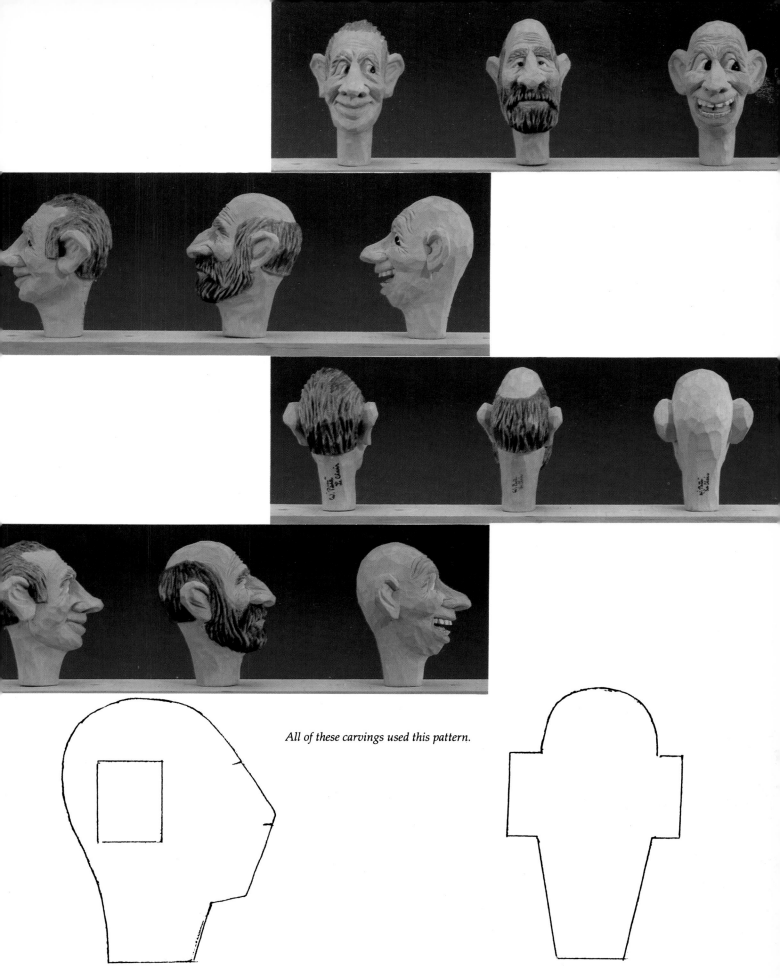

All of these carvings used this pattern.

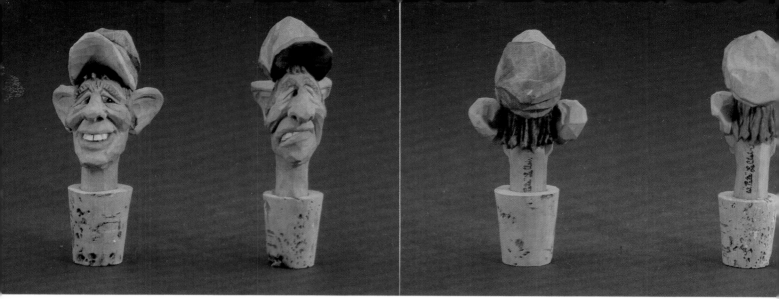

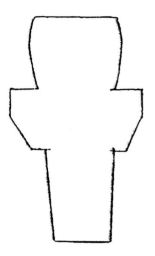

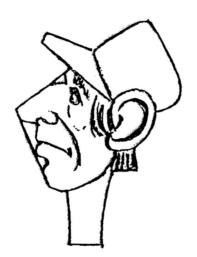

Both of these carvings used this pattern.

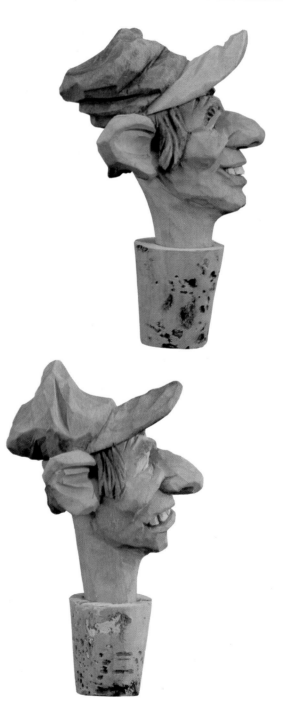

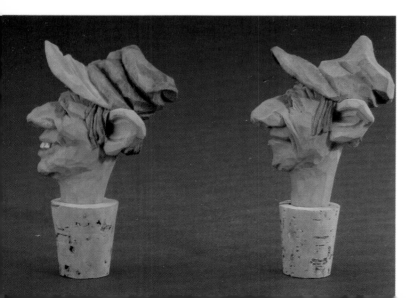

The Gallery

Carved by Tom Flanagan Carved by Ron Boone

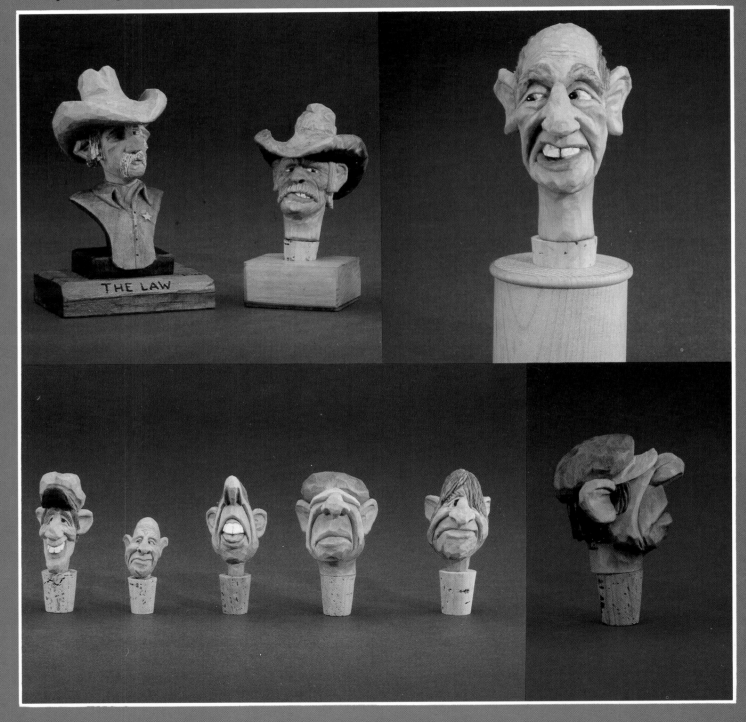

THE LAW

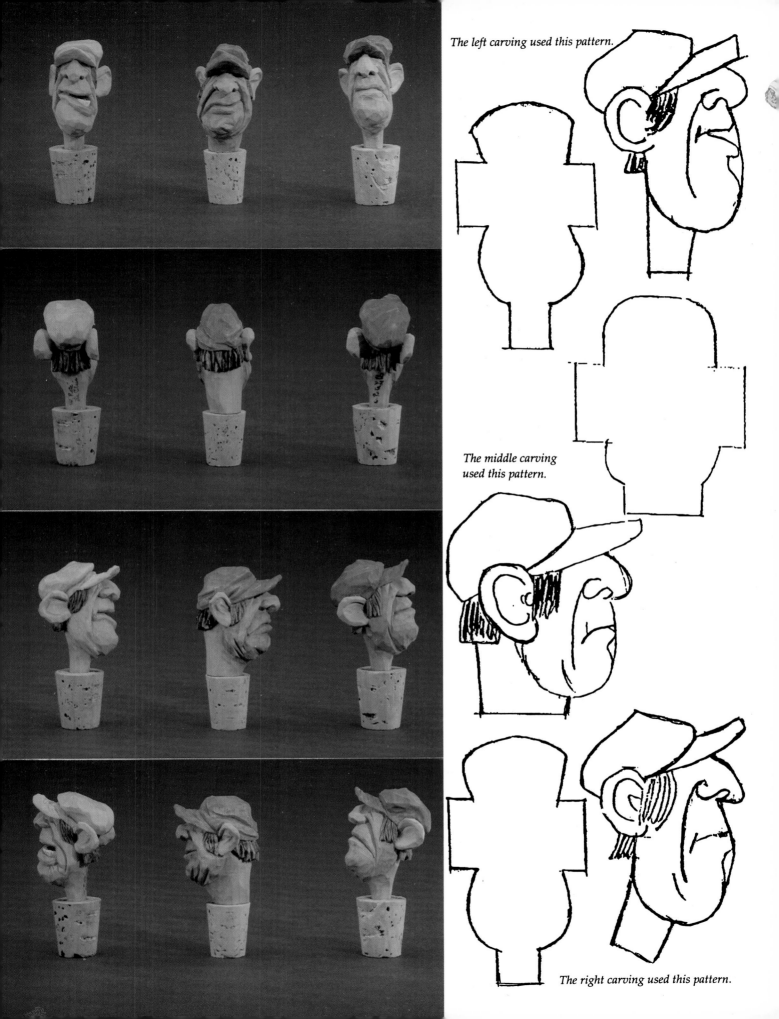

The left carving used this pattern.

The middle carving used this pattern.

The right carving used this pattern.

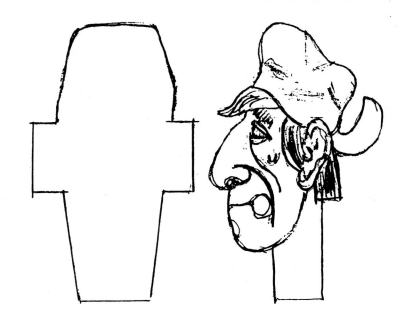
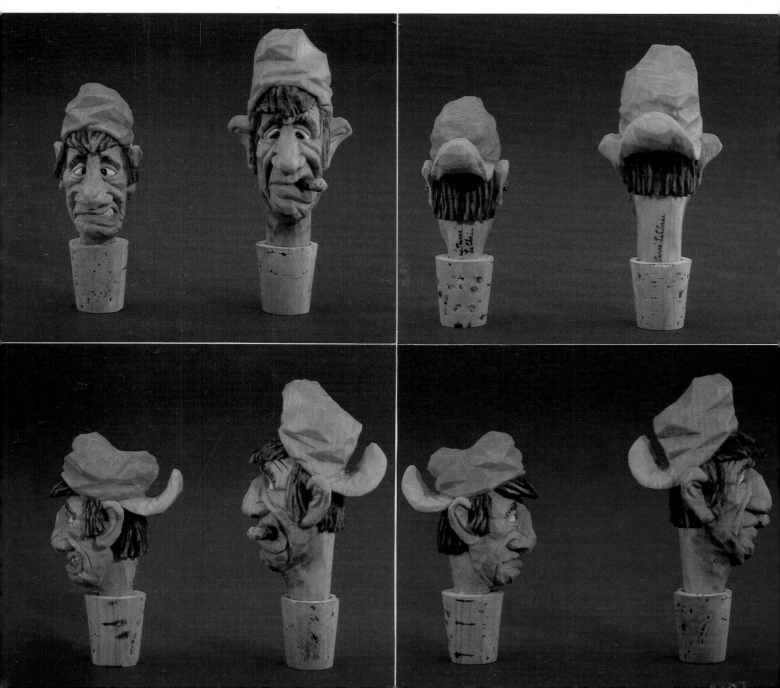

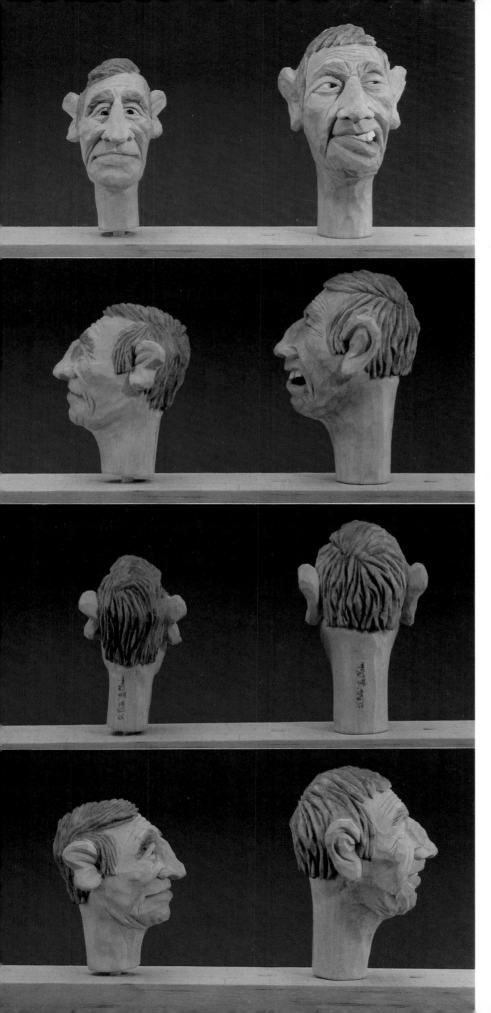

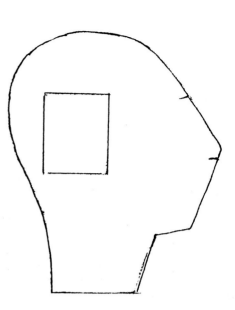

Both of these carvings used this pattern.

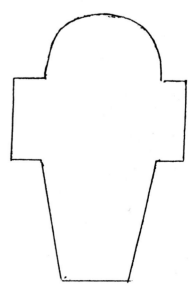

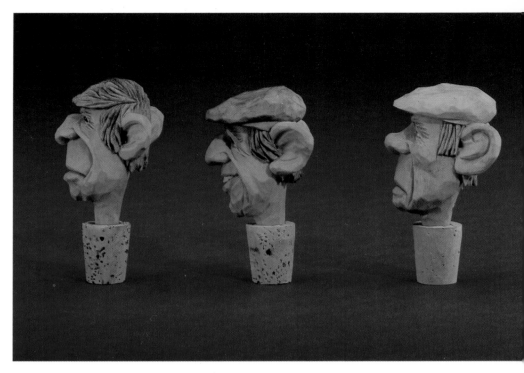

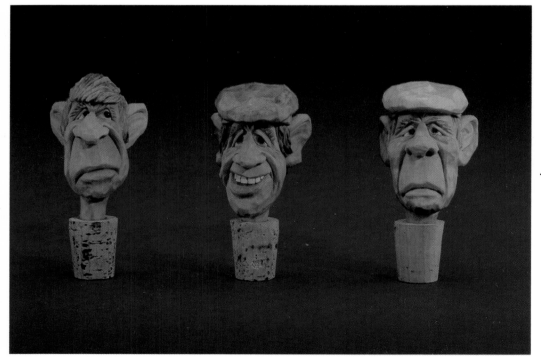

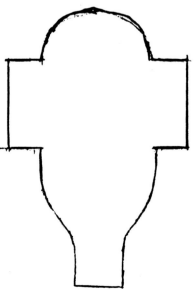

58

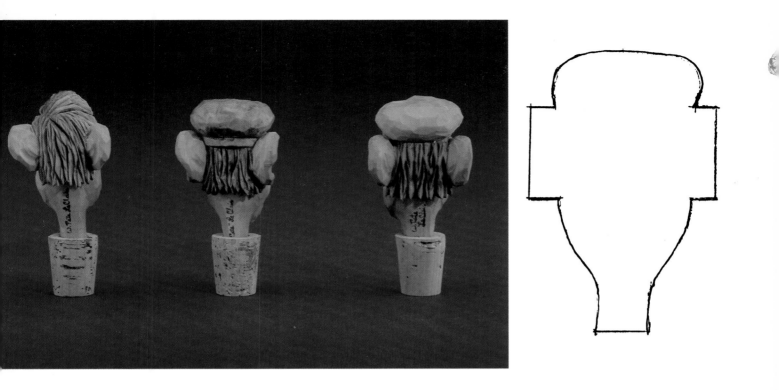

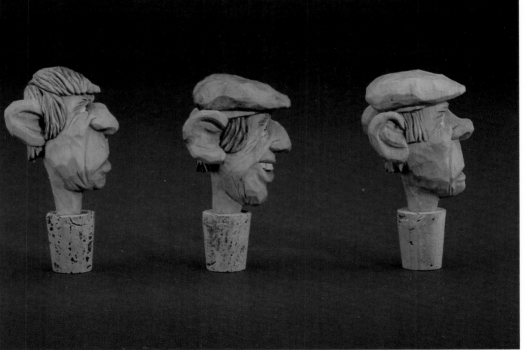

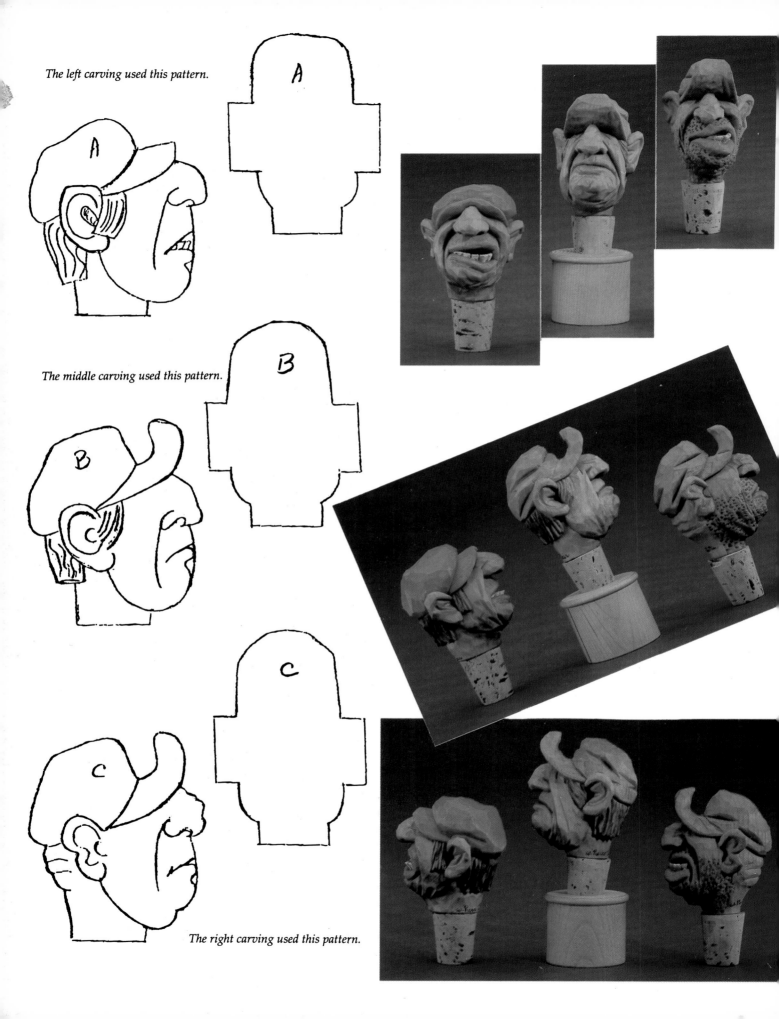

The left carving used this pattern.

The middle carving used this pattern.

The right carving used this pattern.

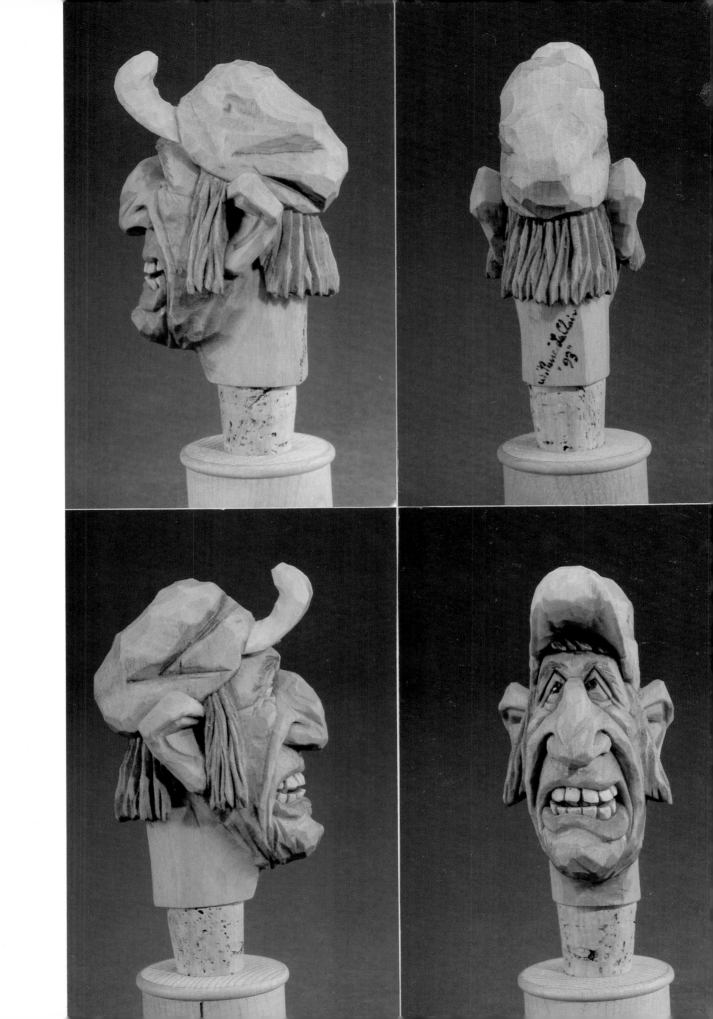

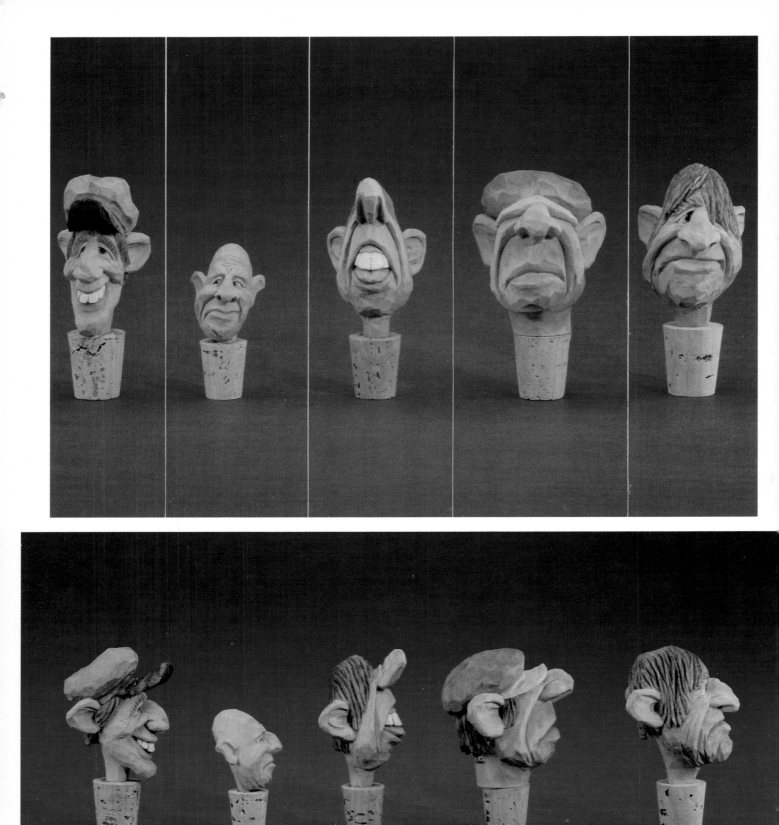

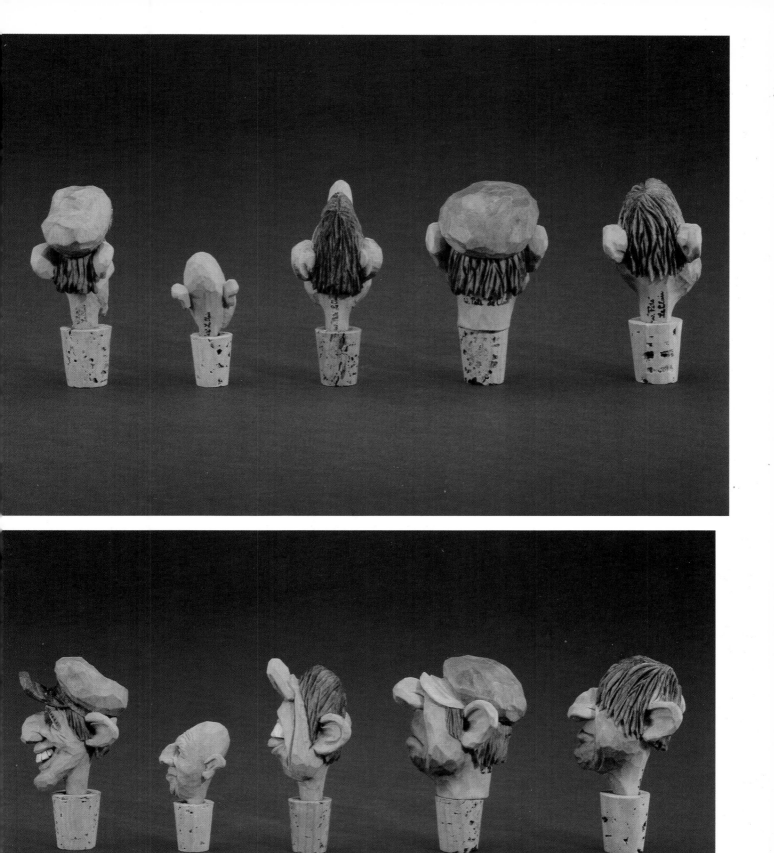

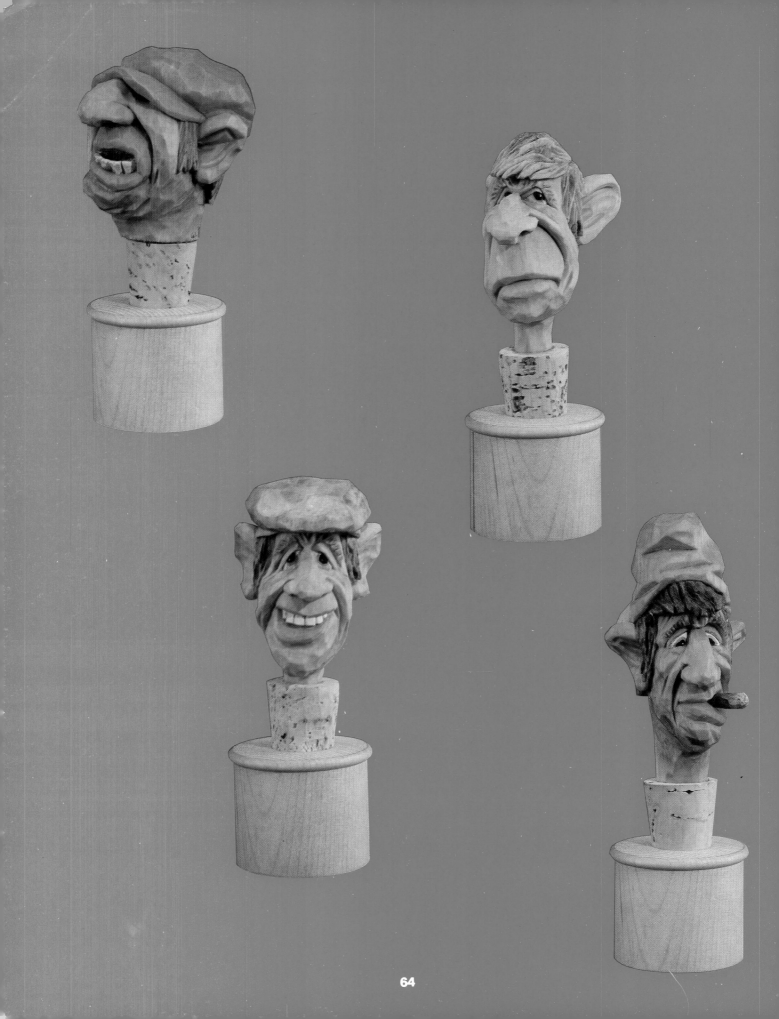